IMAGES
*of America*

# AVIATORS IN
# EARLY HOLLYWOOD

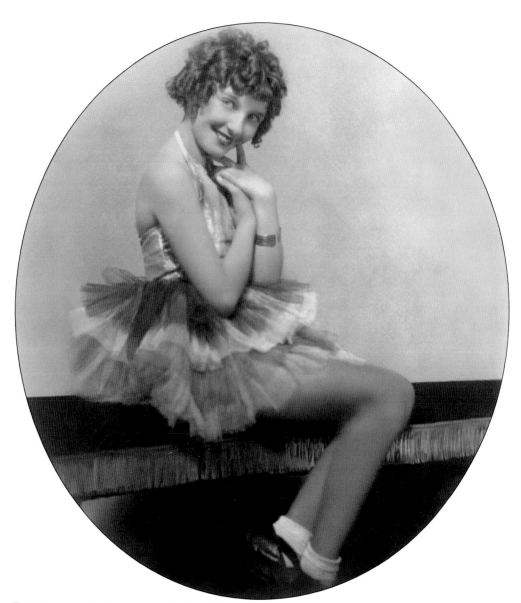

**DEDICATED TO "DAREDEVIL" DELAY'S DAUGHTERS, BEVERLEY AND PATRICIA.** Beverley, seen here in costume, associated with aviator celebrities such as Amelia Earhart, was a Hollywood Meglin Kiddie dancer and performer in the *Land of Oz* (1932), and was an alumna of Hollywood High. She also danced with Judy Garland and Mickey Rooney at venues including the Pantages Theatre. She was also the author's gracious and glamorous grandmother. (Shawna Kelly, DeLay Heritage Collection.)

**ON THE COVER:** Daredevil DeLay, "Big Boy" Williams, and Will Rogers Jr. are pictured in *The Vengeance Trail.* Actor Will Rogers Jr. (left) became a well-respected Southern California politician. Aviator actor B. H. DeLay (right) owned the airfield in Venice, California, where this and dozens of other movie scenes were filmed. DeLay Airfield became the headquarters of Hollywood movie aviation, dominating it in the early 1920s. (Shawna Kelly, DeLay Heritage Collection.)

IMAGES
*of America*

# AVIATORS IN
# EARLY HOLLYWOOD

Shawna Kelly

ARCADIA
PUBLISHING

Published by Arcadia Publishing
Charleston, South Carolina

Printed in the United States of America

Library of Congress Control Number: 2008924118

For all general information, please contact Arcadia Publishing:
Telephone 843-853-2070
Fax 843-853-0044
E-mail sales@arcadiapublishing.com
For customer service and orders:
Toll-Free 1-888-313-2665

Visit us on the Internet at www.arcadiapublishing.com

*This book is dedicated to aviators who broke bones as well as risked and gave their lives to thrill us. To my talented, daredevil-proven brother, Kayden Kelly, who has deeply empowered me, for when someone demonstrates believing in you, it sets you soaring. And to all of my "mothers," including grandmother Beverley, who lived the ideal American life with motion picture perfection; innovative Aunt Dallas; creatively inspiring great aunt Patricia, my mother figure who pushed me to strive higher; and my glamorous, motivational mother, Robin. Also, significantly, this book is dedicated to my much-adored Jonathan Chauvin, who entertainingly zooms into the loop-the-loops of life with me.*

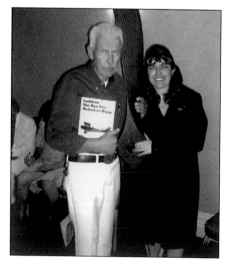

AUTHOR SHAWNA KELLY (RIGHT) AND ART RONNIE. At the 2007 Cinecon Classic Film Festival in Hollywood, Kelly gave a "Hollywood Aviators" presentation. Classic motion picture aviator writer Ronnie was a guest of honor. Actor and author William Wellman Jr., son of William A. Wellman (who directed *Wings*, the first Academy Award Best Picture winner) was the featured speaker. (Shawna Kelly.)

# CONTENTS

# ACKNOWLEDGMENTS

Many rare and spectacular aviator movie photographs and behind-the-scenes stories fly through the following pages. Many of these images are from my Daredevil DeLay–descended family. Other contributions have come in recent years while forming friendships during the Cinecon Classic Film Festival in Hollywood, the San Francisco Silent Film Festival, and at the Essanay Silent Film Museum in Niles, California.

As I shared my thrilling images and stories with notable film and aviation experts, they shared more with me. The daredevil spirit spread and the thrilling photographs and stories escalated fast and furiously.

Never-ending appreciation goes out to my great Hollywood author friend, Marc Wanamaker, with his abounding enthusiasm and impressive Bison Archives aviation image contributions. Robert Nudelman and the Hollywood Heritage organization (DeMille's Barn/Studio Museum) have also earned eternal appreciation. This book is also in memory of Robert, a very loyal friend and legendary Hollywood historian and preservationist who suddenly passed away during the writing of this book.

Art Ronnie, the master Hollywood aviator author, has also significantly influenced this homage to the Hollywood pilots. Highly regarded aviation author John Underwood and dynamic aviation historian "Doc Aeronut" (Phillip Dockter) are also honored contributors.

Actor William Wellman Jr., the author of *Wings* (about his father's making of the very first Academy Award–winning Best Picture), inspiringly joined me in a Hollywood Aviator presentation at Cinecon. His director and combat pilot father, William A. Wellman, also demonstrated extensive loyalty to the Hollywood aviators.

Giacinta Koontz, author of *The Harriet Quimby Scrapbook: The Life of America's First Birdwoman (1875–1912)*, has been both a knowledgeable and glamorous guide on the flight path. The Seattle Museum of Flight's impressive collection has also kindly contributed, with special thanks to Meredith Downs. Supportive thanks go to Margaret and Bartley Bard, actor offspring of Ben Bard—husband of "thriller queen" action hero Ruth Roland. These family friends of the past and present have been heartwarmingly inspiring.

Appreciation also goes to my pop, Jerry, whose father, James Wells, flew with celebrities such as Roy Rogers at the motion picture–popular Burbank and Van Nuys Airports. Heartfelt thanks also must go to my aviator father figure, David Caruso, who taught me as much flying as I could handle as a youth. He especially taught me the respect and loyalty of the aviator.

Errata e-mail (book corrections are welcome): aviators@artzest.com

# INTRODUCTION

## FAME, FILM, FORTUNE, AND FATE

The leading Hollywood aviators may have appeared to be crazed daredevils, but they were actually brave precision pilots. These motion picture aviators were continuously striving to push the limits in aviation, thereby improving safety and glorifying flight through film. Though they may sometimes appear reckless in their pursuits, the leading Hollywood pilots were actually exceptionally methodical overall. They were painstakingly strategic in coordinating their precision-flying film sequences. These precision pilots diagrammed aerials and studied the physics of the air currents by calculating maneuver timing and taking into consideration landing surfaces and angles. Hollywood aviators ambitiously landed many roles, from acting to executive positions. Many additionally earned engineering degrees, designed airplanes, and cautiously instructed flight programs.

In the classic period of the profession, leading Hollywood pilots were often actors as well as precision pilots. Whereas in current times, insurance and legal issues result in specializing them as stunt performers, who are now usually restricted from accepting additional acting roles.

Aviators performed in nearly 200 motion pictures in the Roaring Twenties. Aviators' thrill scenes sold cinema tickets. Aerial scenes were written into movies in order to draw bigger audiences. Sometimes an aviator's performance was written into a motion picture after the film was completed in order to make it more successful.

Both aviation and motion pictures as they are known (as stories, not just narratives) were born in the same year: 1903. The classic period of the aviator unfolds in the Roaring Twenties, when both movie production and aviation innovation were most fast and furious. Also the laws restricting stunting were yet to "stunt" the leading pilots. This was its golden age, when live action aviation performances were uninhibited and fans flocked en masse to behold their onscreen dashing heroes in person. Live performances were celebrated as citywide honors to the aviators, such as Locklear Days. Ormer Locklear, the very first wing-walker, shot to stardom. Hollywood aviators were sent on publicity barnstorming tours between films.

The aviators' behind-the-scenes adventures were often thrilling motion picture stories themselves. Not only did the 1920s roar with the engines of Hollywood aviators, but these pilots often flew with wild lion mascots literally roaring through the air. Aviator mascots were prized morale builders.

Many of the very first licensed flyers were actors. Mary Pickford evolved with the flying craze onscreen and in her real life, personally owning an airplane. Larger than life "Lock" [Ormer Locklear] was asked by many stars to be taken up in the air with him. He also encouraged other stars to join him. Leatrice Joy bravely endured one of Locklear's most daring dives, the "Falling Leaf," a randomly wild, spiral dive. Lock flew Buster Keaton upside down. Charlie Chaplin was jovially "kidnapped" into the air by Mary's brother Jack Pickford and Locklear. The status of actors and directors grew with the thrills that were credited to them.

The most popular airplane used in film work during this period was the Curtiss "Jenny." The Jenny was the first mass-produced aircraft and was surplus sold by the federal government after World War I at a fraction of the original cost. The Standard airplane became popular in films next, and then Fokkers filled the theater of the air. Parachutes were not preferred by the Hollywood

pilots. The spontaneity of not having a parachute strapped on was important for screen realism and kept thrills from being diminished. This was a gesture of loyalty and trust by the pilot to the aircraft owner. A member of the 13 Black Cats association, Gladys Ingle completed over 300 airplane transfers without a parachute.

Shooting for air adventures often started in Hollywood studios and airfields and then ventured out into locations as varied as speedways, train tracks, high building rooftops, ranches, mountains, and beaches, such as Venice Beach. The Trans-Pacific race was sponsored by legendary producer Thomas Ince to enhance the status of Ince Airfield. Professional pilot acting and precision flying originated at the later renamed DeLay Airfield in Venice. Under DeLay's leadership, it became Hollywood's aviator headquarters. Hollywood celebrity–studded events were regularly conducted there. Some Venice pilots migrated to Cecil B. DeMille's airfield and Chaplin Aerodrome, where a number of the most magnificent early air thrillers were filmed. Clover Field (now known as Santa Monica Airport) was the next center of Hollywood aviation. With some overlaps, Glendale airport followed the flight path as the next Hollywood aviator hub. The official opening of Glendale Grand Central in 1929 was a gala affair, including stars of aviation epics, such as Gary Cooper and Jean Harlow, and many celebrities who flew themselves in.

Hollywood aviators Roy and Tave Wilson relocated their hangars from Glendale Airport and opened Wilson Airport on the west side of Burbank Airport. Lloyd/Adams Airport (founded by Hollywood aviator Bob Lloyd from Venice Airfield) and Wilson Airport were both absorbed into Burbank Airport. Paul Mantz operated motion picture aviation services for an extended period at Burbank. The Hollywood pilots were then based at Van Nuys Airport for the long term. Years later, Tallmantz Aviation (founded by Frank Tallman and Paul Mantz) was based at Orange County Airport (now John Wayne Airport).

The B. H. DeLay Company founded the standards of aerial film performance such as rates and aerial scenarios. Wing walking and flying for camera ships was standardized at $40 an hour, which amounts to nearly $500 an hour at current rates. Transfers from airplane to trains, planes, or automobiles were $100 extra per change, which would be over $1,000 now. Since DeLay Airfield was located in Venice, a popular resort and exhibition location, the aviators could remain performing in the vicinity virtually year-round.

DeLay's Airfield established a professional foundation to build on, and this evolved into aviator associations solidifying further standards of quality, rates, and safety. Aviator associations such as 13 Black Cats, Ninety-Nines, and the Associated Motion Picture Pilots united and significantly extended the aviator actor's power in the entertainment field. A somewhat similar sounding group, billed as the Five Blackbirds, was an African American exhibition team headed by Hubert Julian.

"Bon" MacDougall founded the 13 Black Cats association in 1925. Demonstrating defiance of superstition and death, they built morale and bonded as a team. The 13 Black Cats' rate for upside-down flying or changing from airplane to airplane was also $100 per change. The flat rate for a fight on the upper wing between two aerialists, including knocking one off, was $225. The flat rate for a spinning crash or a crash into a building or trees was $1,200. The most expensive aerial work was $1,500 for blowing up a plane in midair with the pilot parachuting out.

The Ninety-Nines aviatrix association was founded in 1929 and performed for newsreels, motion pictures, exhibitions, and frequently in races. Their first president was none other than Amelia Earhart. Aviatrices were inspired to form the Ninety-Nines organization at the famous first Powder Puff Derby of 1929. The derby took off from Santa Monica, California, and raced to Cleveland, Ohio. Louise Thaden was nearly fatally wiped out from carbon monoxide poisoning by the inadequately engineered exhaust angle of her Travel Air's engine. This serious situation saved future lives, since Travel Air mechanics modified their engines in the middle of the race. Thaden then soared on to win.

Legendary "Pancho" Barnes founded the Associated Motion Picture Pilots (AMPP) in 1931. Some of the charter members included renowned pilots Frank Clarke, Al Wilson, and Dick Grace.

The AMPP aviator rate for movie work was set at a minimum of $350 a week, yet some of the leading pilots earned double or triple that amount. AMPP members were the strongest force in setting film aviation pricing, improving safety through increasing the authority of the aviators, assisting each other in attaining work, and preventing producers from seeking less-qualified pilots. Initially, Paul Mantz had been underbidding motion picture pilot union rates. Therefore, when he wanted to join the AMPP union to gain better rates, he was challenged to prove himself more than usual. Mantz finally gained AMPP union acceptance by setting a world record of 40 consecutive g-force (head-throbbing) outside loops.

The Hollywood Aviators exuded such irresistibly dashing heroism that many of the leading female stars fell for them. Aviation advocate Mary Pickford married the star of *Wings* (1927), Buddy Rogers. A star of *Hell's Angels* (1930), Ben Lyon, married aviatrix and popular star Bebe Daniels. Charlie Chaplin's leading lady, Edna Purviance, was especially appreciative of the aviators. Purviance spent a significant amount time on the airfields, collected albums of aviator photographs, and also married an aviator. Viola Dana transitioned from a relationship with superstar actor Buster Keaton to star aviator Ormer Locklear. Eccentric aviator producer Howard Hughes also embarked on extensive romances with actresses and aviatrices alike.

Even though aviators were awarded the title, the term barnstorming is derived from early Shakespearian actors, who sometimes performed in barn-like structures and toured from town to town. The Hollywood aviators and barnstormers displayed deep loyalty and were sometimes viewed as "cowboys of the sky." Early aviation had equestrian influences, from the phrases such as mounting the airplane to an airplane's knightly insignia, as well as the pantsuit apparel of jodhpurs. Barnstorming and aerial exhibitions involved theatrical racing, record breaking, mock battles, Western events, and star-celebrity performances. Live performances also grew into derbies, rodeos, air circuses, and other theatrical extravaganzas.

Movie studios that frequently shot aviation themes during the Roaring Twenties were Universal, Fox, and Paramount. Colorful characters of the newsreels and live performances were from the world of magic, music, and Westerns. Princess Tsianina showered notes from the air with Daredevil DeLay and entertained America. Operatic superstar Luisa Tetrazzini exalted the glory of flying through the clouds and sang the high C with Locklear and DeLay. The legendary motion picture magician, Harry Houdini, was the first to fly in Australia and starred in the Universal picture *The Grim Game* (1919) with electrifying real-life crash footage.

Newsreel filming reached wild levels, such as a Native American's over-the-top aerials including Frank Clarke's famous building fly-off. Chief White Feather was compelled to prove himself through hanging from an airplane by his hair. He prepared by dangling from his braided hair for over a couple hours from the ceiling of the hangar at Venice Airfield. The chief was determined to prove himself next by releasing 10 chutes consecutively while skydiving on a single jump; however, he ran out of altitude on the sixth chute and fatally merged with the earth. Frank Clarke was quite disappointed, especially since he was planning exhibitions with the hair-hanging chief, sponsored by hair repair companies.

Fearless aviatrices were performing sensational motion picture scenes and exhibition thrills from the very early days. Bessie "Queen Bess" Coleman had to move to France to become the first African American licensed pilot, and then she starred in a flying exhibition troupe. Blanche Scott was the first American woman to pilot a solo flight in 1910 and became the first female test pilot. She performed inverted flight and "death dives." Scott played a lead role in *The Aviator and the Autoist Race for a Bride* in 1912. Since the earliest airplanes could be built without brakes, Scott nearly smashed into the cinematographer in one of her scenes, but she skillfully halted the airplane nose to nose with the camera, achieving the most overblown close-up imaginable.

Charles Lindbergh's 1927 Atlantic solo flight, an international record, sent aviation into a fevered pitch. The classic period of the aviator culminated in two spectacular film epics, *Wings* and *Hell's Angels*. *Wings* was the very first Academy Award Best Picture winner and set the aerial standard for epics. It inspired much of the film aviator acting and precision flying rage that followed.

Howard Hughes watched *Wings* repeatedly and was inspired to strive for the ultimate aviation war movie with as realistic air combat action as possible. In 1927, he rounded up what became the largest private air force in the world on farmland in Van Nuys to film *Hell's Angels*.

*Hell's Angels* was also record setting in the extreme output of film footage shot and financial investment. The film's lavish premiere also soared to the greatest screening heights at Grauman's Chinese Theatre in Hollywood. Howard Hughes, the aviation movie producer and consummate perfectionist, oversaw shooting of 300 times more footage than what landed in the final film. *Hell's Angels* was first shot as a silent and then remade with sound. Three flyers also gave their lives in the making of this extreme picture.

The first aerial sabotage on record, of famed aviator actor B. H. DeLay, is a real-life unsolved mystery. Multiple motives involved celebrity relationship catalysts to wranglings over his rapidly expanding airfield assets. This intrigue is detailed in *The Last Squadron* section of the last chapter, since DeLay's aerial sabotage influenced this motion picture.

The aviators were intensely driven to perform precisely in films. Leading pilots such as Daredevil DeLay and Dick Grace stoically refused to be paid if they did not provide the exact performance that was scripted—even if they were seriously injured during the filming. This was the case when Dick Grace suffered broken ribs and torn muscles in the one performance he termed a "disgrace."

One of the most spectacular crashes deeply affected Hollywood. This was the final aerial in *The Skywayman* (1920), which called for Ormer Locklear to perform a spiraling dive at night over DeMille Airfield from 5,000 feet with wing flares and searchlights illuminating the aerials. Locklear and Skeets Elliott flamed out in a fatal blaze of glory on this last night of filming.

Luckily these leaders were rarely off in their precision performances. However, the leading motion picture pilots broke many bones thrilling their audiences. Ultimately, the leading Hollywood aviators nearly all gave the ultimate gift of their lives in creating realistic motion pictures.

*The Portal of Folded Wings: Shrine to Aviation* is a beautiful aviator monument featured next to Burbank Airport and Valhalla Cemetery. Barnstormer Carl Squire and motion picture aviator Mark Campbell are enshrined in the portal, along with exhibitionist Matilde Moisant and racer celebrity aviatrix "Bobbi" [Evelyn] Trout. Many of the earliest legendary aviation innovators are also enshrined in the portal.

The legacy of Hollywood aviators includes creating movie realism and heroism as well as industry advancements in aviation safety. The epics and retrospectives memorialize prominent Hollywood aviator qualities: courage, passion, precision, and loyalty. The following chapters dive more into details of the pilots' thrill-filled lifestyle, briefly highlighting their bravery onscreen and behind the scenes.

To those young warriors of the sky whose wings are folded about them forever, this picture is reverently dedicated.

**WINGS PROGRAM AVIATOR DEDICATION.** Pilots whose wings have "folded" received this tribute. A significant number of Hollywood pilots broke their bones and ultimately gave their lives for motion pictures. Leading Hollywood aviators aspired to the highest precision flying, which was akin to the warrior's risks of life and limb. (Robert Nudelman, Hollywood Heritage.)

# One

# HOME BASE
## CELEBRITY AIRFIELDS
## TO GRAND AIRPORTS

Airfields of the Hollywood aviators were often motion picture sets. Mostly open cropland at the time, the San Fernando Valley of Los Angeles was the setting for hundreds of feature films and shorts.

Legendary director Cecil B. DeMille was so immersed in aviation that he operated three airports in the Hollywood vicinity. *The Great Air Robbery* (1919), the first notable full-feature aviation film, was shot on DeMille Airfield No. 1 on Melrose Avenue. A significant amount of high-flying aerial filming was shot at DeMille Airfield No. 2 on Wilshire Boulevard, including the sensationally triumphant *The Grim Game* (1919), starring "escapologist" Harry Houdini.

Chaplin Aerodrome also operated on Wilshire Boulevard, adjacent to DeMille Airfield No. 2. This actor aviator's aerodrome was a dynamic filming location too, which specialized in amphibious aircraft.

Ince Airfield, located next to Venice Beach, was owned by the "Father of the Western," pioneering producer Thomas H. Ince. Hollywood aviator B. H. DeLay was the manager of Ince Airfield. DeLay acquired the airfield while continuing to work on Ince Studio films. Ince Airfield became the professional center of Hollywood aviation under DeLay. Eventually working with over 25 movie companies, DeLay innovated several film firsts. When DeLay was sabotaged, most of the Hollywood pilots migrated to Clover Airfield (now Santa Monica Airport). Glendale Airport later gathered many of the greatest celebrity aviators in motion pictures and gala exhibitions.

Subsequently, Hollywood aviator Bob Lloyd's Lloyd/Adams Airport became absorbed into Burbank. After that, Burbank Airport's Wilson and Mantz motion picture service companies were engaged by nearly every Hollywood studio.

Van Nuys was a continuous aerial filming hot spot, and *Hell's Angels* was filmed on its fringes. Mines Field began as a bean field and was transformed into Los Angeles Municipal Airport (later LAX: Los Angeles International Airport). This transformation was spurred by years of hosting national air races including acrobatic performances by Charles Lindbergh and 13 Black Cats member Art Goebel setting aviation records. In later years, Orange County Airport (later John Wayne Airport) was where Tallmantz Company housed the crowning tribute to film aviation, the Movieland of the Air Museum.

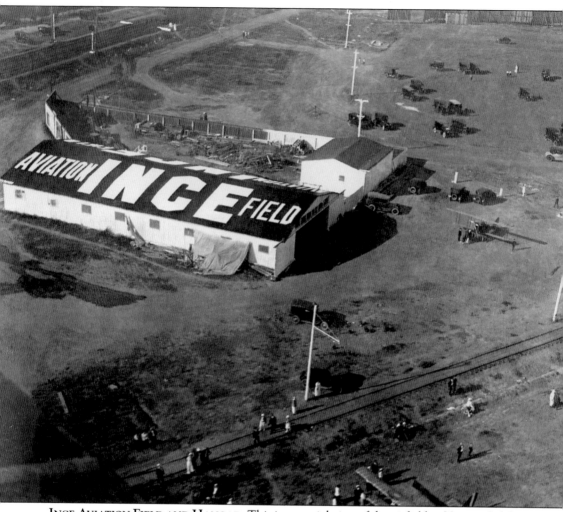

**INCE AVIATION FIELD AND HANGAR.** This is an aerial view of the airfield in Venice, California, previously owned by Thomas H. Ince. When it was named DeLay Airfield in 1920, Ince's stunning signs were loyally retained. Airfield owner B. H. DeLay also acted and stunted in Ince Studios films such as *Skin Deep* (1922). DeLay eventually worked with over 25 movie companies including Paramount, Universal, Fox, Warner Brothers, Vitagraph, and Pathé. (Marc Wanamaker, Bison Archives.)

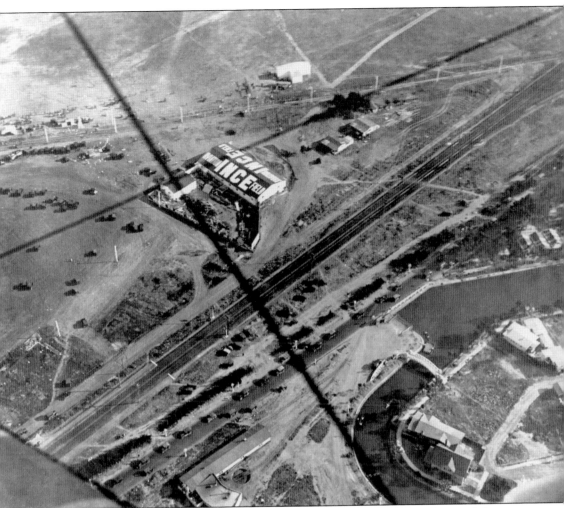

DeLay Airfield: Hollywood Aviator Headquarters. Westerns, comedies, and dramas were filmed at DeLay Airfield. It was well located by the picturesque canals of Venice Beach in California (lower right). The finest performance pilots from around the country were drawn to DeLay Airfield. Its school also specialized in motion picture flying. In one of B. H. DeLay's movie contracts, he was engaged to rescue the heroine from the top of a burning building and at the same time crash into this burning building's tower where the villain was hanging on to a flagpole, thereby knocking over the tower and causing the villain to plummet to his death. This fast and furious filming sequence was successfully performed with the aid of a set constructed at the DeLay Airfield. The airfield also held numerous celebrity benefits, especially benefiting disadvantaged children and disabled war veterans. (Marc Wanamaker, Bison Archives.)

**DELAY AIRFIELD NEXT TO VENICE BEACH.** Notice Cecil B. DeMille's Mercury airplane at the right with the "CB" logo. DeMille and Chaplin Airfields would send their most daring pilots over to Venice Airfield for exhibitions and motion pictures. (Marc Wanamaker, Bison Archives.)

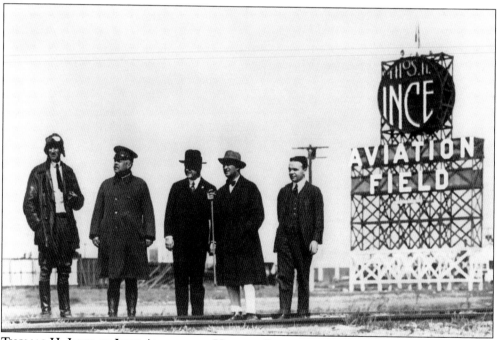

**THOMAS H. INCE AT INCE AIRFIELD IN VENICE, CALIFORNIA.** Ince (second from the right) is production planning with company crew. Venice drew theatrical aviators since the beginning of exposition, such as pilots visiting from the first national 1910 Dominguez Air Meet. Frank Stites and Frank Champion were a couple of the earliest performers. Abbot Kinney, the "Father of Venice," encouraged aviators to perform at his Venetian amusement utopia by the beach. This site became an official airfield in 1913, even though aviators performed here since the very beginning of touring exhibition flight. (Marc Wanamaker, Bison Archives.)

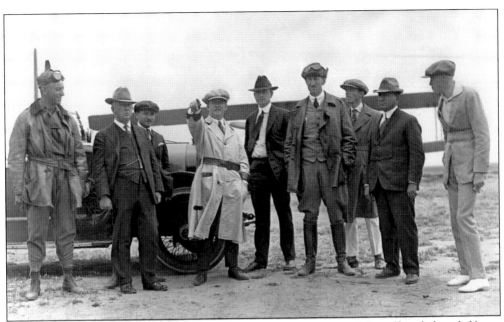

INCE AIRFIELD IN VENICE, CALIFORNIA, 1919. Producer Thomas H. Ince (fourth from left) was the Henry Ford of mass film production. He created the movie production system of specialization, enabling the production of several films simultaneously at a studio. He standardized the "shooting script," which defined actors' locations in scenes, and the "scene plot," which became the script for interiors and exterior filming sets. His most revolutionary studio system creation was the delegation of the specialized roles of writer, director, and film cutter. Ince's airfield manager B. H. DeLay (left) became the next owner of the Venice Airfield and innovated breakthroughs in motion picture aviation. (Marc Wanamaker, Bison Archives.)

CHECK FROM THOMAS INCE BACKING THE TRANSPACIFIC VENICE RACE. The race publicity enhanced the reputation of Ince Airfield. This amount of $50,000 translates to over $500,000 today. The race award destination was Hawaii or Japan. No flier was able to win the stringent race competition, so it was eventually discontinued. (Marc Wanamaker, Bison Archives.)

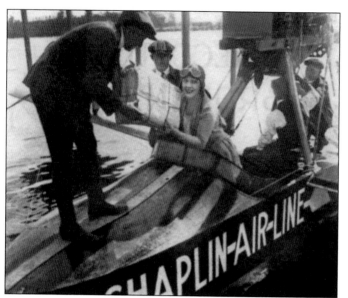

**EDNA PURVIANCE IN A CHAPLIN AIRLINE SEAPLANE.** Purviance, Charlie Chaplin's premiere leading lady, spent an extensive amount of time on the motion picture aviator's airfields and ultimately married pilot Jack Squire. Her first five films with Chaplin were at the Essanay-West Studio in Niles (San Francisco Bay Area), California. The Essanay Theatre currently offers quality classic films on a regular basis. (Lita Hill of the Purviance family.)

**CHARLIE CHAPLIN AT CHAPLIN AERODROME.** Actor Syd Chaplin (third from left), brother and agent of Charlie Chaplin (second from left), co-owned Chaplin Aerodrome. Fellow Essanay Studio actor Max Linder (far left) was also a screenwriter, producer, and director. After Max Linder's passing, Chaplin dedicated one of his films to him, stating, "For the unique Max, the great master—his student Charles Chaplin." The other Aerodrome co-owner was Emory Rogers, who originated his operations from Venice Airfield. (Hollywood Heritage Museum.)

**PONY BLIMP AT DEMILLE'S MERCURY AIRFIELD.** The Goodyear Pony Blimp was previously at DeLay Airfield June 6, 1920, for an aerial circus. Roy Knabenshue, the United States' first dirigible pilot, flew over Glendale. Blimps were moored in hangars at Ross Airfield in Arcadia, California, which also operated a dirigible school. (Hollywood Heritage Museum.)

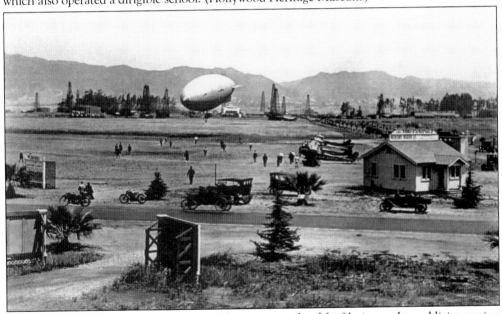

**AERONAUTICS AT DEMILLE'S AIRFIELD.** Blimps were utilized for filming and to publicize motion pictures. DeMille built his first airfield at the southwest corner of Melrose Avenue and Crescent Boulevard (now Fairfax Avenue). Cecil B. DeMille's Mercury Aviation Company Airfield No. 2 (pictured) location was at Wilshire Boulevard and Fairfax Avenue. DeMille established his third airfield in Altadena. He bought Curtiss JN Canucks and six JN-4Ds, all affectionately known as Jennies, to fill his airfields. (Delmar Watson Photography Archives.)

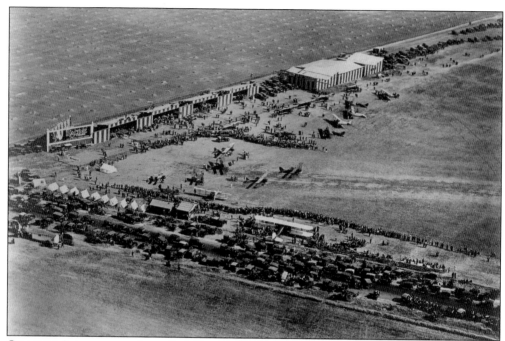

CHAPLIN AERODROME. Actor Syd Chaplin, brother and agent of Charlie Chaplin, co-owned Chaplin Aerodrome. It was south of Wilshire and west of Crescent (now Fairfax Avenue) in 1919. The adjacent field was Cecil B. DeMille's Mercury Airfield. The Aerodrome operated until April 1920, when Emory Rogers took it over. When DeMille left his Mercury Airfield north of Wilshire in 1922, it was also added to Rogers Airfield, which operated there until 1923. (Marc Wanamaker, Bison Archives.)

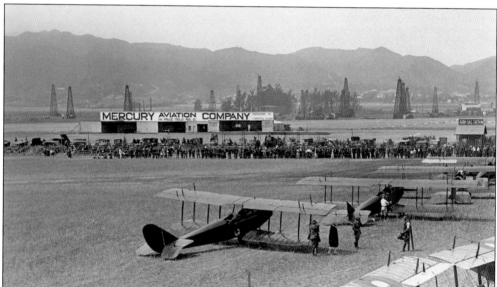

DEMILLE AND CHAPLIN HOME BASES. Notice the Mercury Aviation Company signs in the left background across from the Chaplin Aerodrome signs on the right. The proud Mercury sign reads, "Pioneers in Commercial Aviation." The roundels emblazoned on the aircraft in the foreground at right are United States insignia. (Marc Wanamaker, Bison Archives.)

18

**DIRECTOR CECIL B. DEMILLE'S JUNKERS AIRPLANE.** This J-L (Junkers-Larsen) was one of the first all-metal passenger airplanes. DeMille formed Mercury Aviation Company in late 1918. It is still in existence today as a hangar and fuel-service provider for corporate aircraft. (Shawna Kelly, DeLay Heritage Collection.)

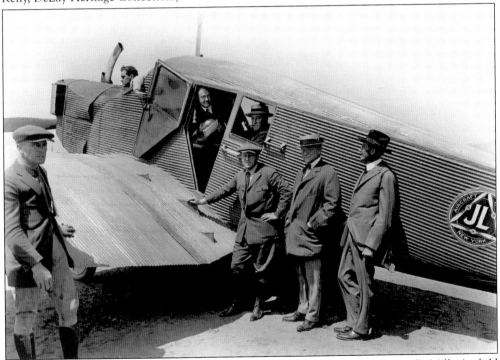

**CECIL B. DEMILLE WITH HIS REVOLUTIONARY JUNKERS.** This J-L was flown to DeMille Airfield by the American "Ace of Aces," Eddie Rickenbacker (behind the window). Founding Paramount producer Jesse L. Lasky is pictured in the aircraft's doorway. DeMille's aircraft premiered at the infamous first-ever fly-in on April Fool's Day in 1921. (Marc Wanamaker, Bison Archives.)

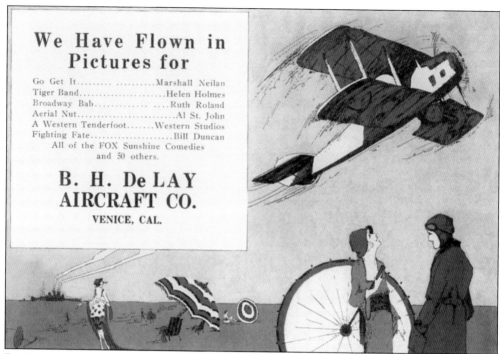

**B. H. DELAY'S FILM PORTFOLIO.** These are credits for some of DeLay Aircraft Company's motion picture aviation accomplishments working with over 25 film studios. The illustration depicts leading ladies and fans who often flocked around the motion picture pilots and lounged on Venice Beach, mesmerized by their death-defying feats. Note that *Broadway Bab* is the preproduction title and book that inspired the motion picture *Ruth of the Rockies*. (Shawna Kelly, DeLay Heritage Collection.)

**PUBLICITY OF DEMILLE'S AND CHAPLIN'S AIRFIELDS.** The celebrity filming airfields were often promoting their exhibitions, specialties, and advancements. Chaplin Aerodrome's specialty offering was sea-worthy amphibious aircraft such as the Curtiss Seagull. The Chaplin Aerodrome conducted a regular route to Avalon on Catalina Island. (Robert Nudelman, Hollywood Heritage.)

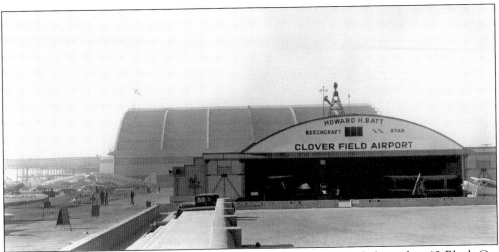

CLOVER FIELD (SANTA MONICA AIRPORT) IN 1937. The hangar belonged to 13 Black Cat Hollywood aviator Howard Batt. When DeLay Airfield was dismantled after DeLay's sabotage, most of the Hollywood pilots moved their hangars to Clover Field and aviation motion pictures took off again. (Marc Wanamaker, Bison Archives.)

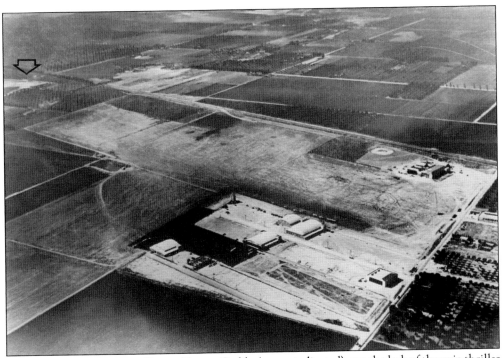

VAN NUYS AIRPORT AND CADDO FIELD. Caddo (arrow indicated) was the hub of the epic thriller *Hell's Angels*. An airport film location favorite, Van Nuys (called Metropolitan before 1957) is in the foreground. The founding manager, Waldo Waterman, originated from the Hollywood aviator headquarters of DeLay Airfield. The hangar in the closing scene of *Casablanca* was filmed on Waterman Avenue. The Air National Guard stationed there referred to itself as the "Hollywood Guard" because it participated in numerous motion pictures. Van Nuys remains home to vintage airplanes and special projects. (Amélie Archives.)

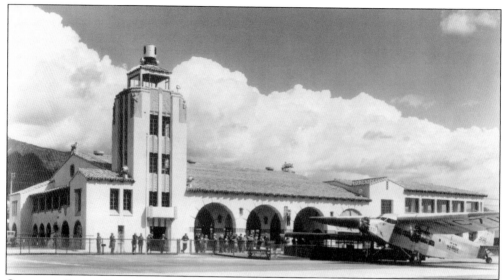

GLENDALE GRAND CENTRAL AIRPORT. Amelia Earhart and actor aviatrix Andrée Peyre performed as a pair at the opening of Glendale Airport in 1923. The Wilson Brothers Company hangar was near Slate's dirigible hangar. The airport became Grand Central in 1929 and hosted the Lindbergh Line. Howard Hughes and Douglas "Wrong Way" Corrigan attended the airport's Plosserville School. After establishing Hughes Aircraft Company at Glendale, Hughes then built his H-1 racer and set speed records. Two original hangars still stand with the terminal building that are under renovation by The Disney Company. (Ron Dickson, Godickson.com/ahsfv.htm.)

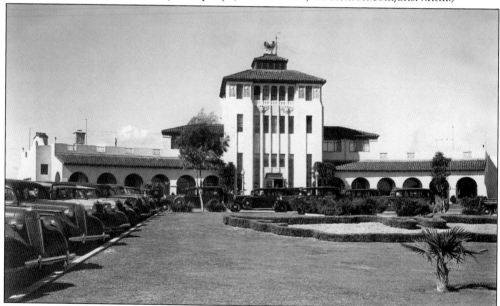

CELEBRITIES AT "BOB HOPE" BURBANK AIRPORT (UNION AIRFIELD IN 1937). Celebrated aviators Wiley Post, Roscoe Turner, and Charles Lindbergh were based at Burbank, with Amelia Earhart also hangaring her Lockhead there. Paul Mantz operated a motion picture aviation company at Burbank, which engaged other Hollywood aviator greats such as Frank Clarke. Both Mantz and Wilson's aviation companies were used by nearly all of the movie studios. The Wilson (Tave and Roy's) Hangar still stands on Sherman Way. (Marc Wanamaker, Bison Archives.)

# Two

# AVIATOR ACTORS
## ACING THE MOTION PICTURES

Hollywood aviators were so popular in the classic period of Hollywood that they were treated like superstar action heroes. At times, they commanded more fanfare than the leading stars. The leading aviators were stunt pilots as well as actors, who often played the roles of aviators, and sometimes were the top star of the motion picture.

The wing-walking king, Ormer Locklear, rose to stardom meteorically but suddenly flew out in a spectacular blaze of glory. Al Wilson was the first recognized professional motion picture aviator. Not only did he teach Cecil B. DeMille to fly and manage his airfield, Wilson also starred in films and became a producer. Dick Grace was the quintessential "Crash King," who broke more than 80 bones in his body, including his neck, for aerial films. Grace performed all of the piloted crashes for *Wings*. Frank Clarke acted the part of von Bruen and was the chief aviator of *Hell's Angels*. Clarke courageously ascended to "King of the Air" status. Daredevil DeLay, the de facto "father of the professional motion picture aviators," owned the airfield that became the headquarters of Hollywood aviation. He also founded the standards for motion picture flying and performed at least half a dozen aerial firsts for motion pictures. DeLay's film feats included the first exchange of a person from an automobile to an airplane, and the first onscreen knockdown of a building with an airplane. Paul Mantz compiled one of the most extensive motion picture careers of any pilot and operated a film aviation museum.

The leading Hollywood aviators exhibited a great depth of loyalty and depended on each other technically for their stunt performance success. They even saved each other's lives during performance slipups in midair. On the ground, they were often landing each other film roles.

Associations such as the 13 Black Cats, Ninety-Nines, and the AMPP united pilots and substantially increased their power in the film industry. The following compiled headshot sheet is a notable who's who of Southern California and motion picture aviators of the early 1920s. The pilots range from directors and producers to aerial cinematographers, actors, aerialists, as well as speed kings and queens.

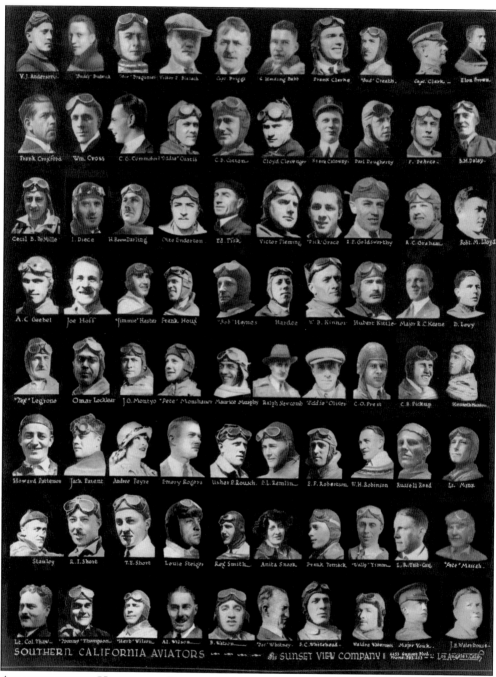

**AVIATORS OF THE HOLLYWOOD REGION.** This compilation was featured in scenes at the Pacific Aviation School of the movie *Air Circus* (1928). Many of the most celebrated in classic Hollywood and aviation are pictured. In alphabetical order are Frank Clarke, B. H. DeLay, Cecil B. DeMille, Victor Fleming, Art Goebel, Dick Grace, Ormer Locklear, Andrée Peyre, Anita Snook, and Al Wilson. Nearly all of the pilots pictured worked on motion pictures, either as aerial photographers, directors, producers, precision aviators, actors, or in a combination of these disciplines. (Shawna Kelly, DeLay Heritage Collection.)

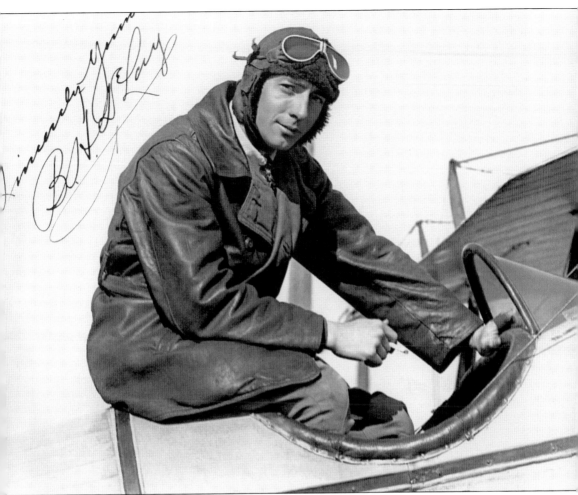

**ICONIC HOLLYWOOD AVIATOR DAREDEVIL DELAY.** The "father of professional motion picture aviators," B. H. DeLay owned the airfield in Venice where many films were shot. DeLay's suave and confident image reveals his passionately driven nature derived from his French American heritage. He worked on more than 50 films as an aviator actor, stunt pilot, and coordinator. DeLay Airfield became the headquarters of Hollywood aviation and dominated the field of motion picture aviation in the early 1920s. DeLay innovated at least half a dozen aerial firsts for motion pictures, including the first change from airplane-to-train and the sequence of reverse train-to-airplane. Another DeLay Company first was transferring from saddle-to-airplane, as well as auto-to-airplane. Daredevil DeLay was also the first to knock down a building with an airplane onscreen. (Shawna Kelly, DeLay Heritage Collection.)

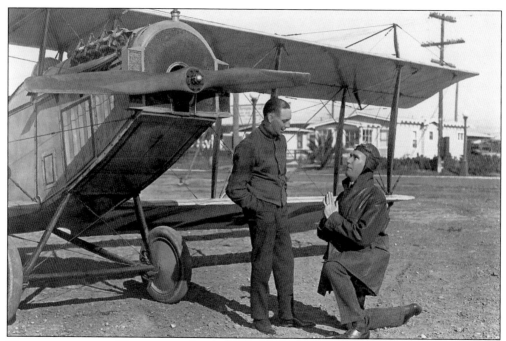

**VENERATION OF THE HOLLYWOOD AVIATOR.** Hollywood aviators were treated with great respect and admiration. Santa Monica's First Methodist Church's Reverend Sutherland gave multiple sermons about B. H. DeLay, who he invited as a guest of honor. DeLay earned engineering degrees from the University of California and the University of Heidelberg in Germany. DeLay also operated a motion picture pilot school. (Shawna Kelly, DeLay Heritage Collection.)

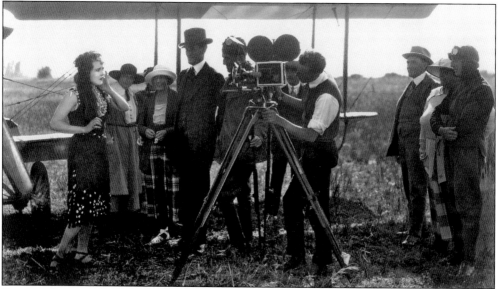

**FILMING *RUTH OF THE ROCKIES* ON DELAY AIRFIELD.** Ruth Roland (left) is the glamorous action star in the ornate costume. Aviator actor DeLay's airplane is in the scene (far left), displaying a wing above. DeLay is on the right (aerial stunt coordinating), next to his parents Charles and Matilde DeLay. The tall gentleman (center) is the best-selling author and screenwriter Harold Bell Wright. *Ruth of the Rockies* was released August 29, 1920. (Shawna Kelly, DeLay Heritage Collection.)

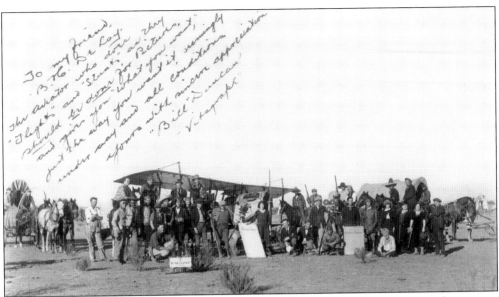

**DIRECTOR WILLIAM DUNCAN APPRECIATING AVIATOR DELAY.** A Western cast and crew pose by B. H. DeLay's airplane. William Duncan was a leading star who became a screenwriter and director. A number of the Hollywood pilots worked in Western motion pictures. Some aviators had Western backgrounds as cowboys or were involved with rodeos or equestrian events, including Frank Clarke and Ira Reed. (Shawna Kelly, DeLay Heritage Collection.)

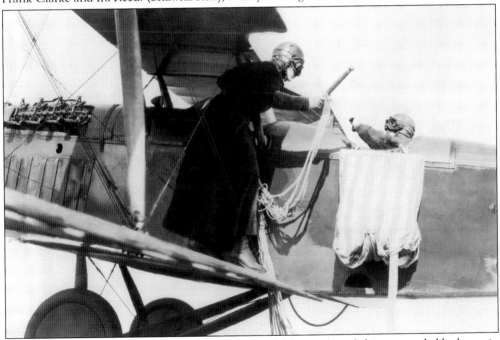

**HELEN HOLMES ACTING WITH B. H. DELAY.** Helen Holmes is brandishing a rope ladder baton in front of DeLay in this scene from *The Tiger Band* in 1920. Holmes produced and starred in this Warner Brothers film. Known as the "Queen of the Railroad," she starred in numerous thrilling railroad movies and performed nearly all of her own athletically demanding stunts. Her characters were quick thinking and known for their heroic inventiveness. (Shawna Kelly, DeLay Heritage Collection.)

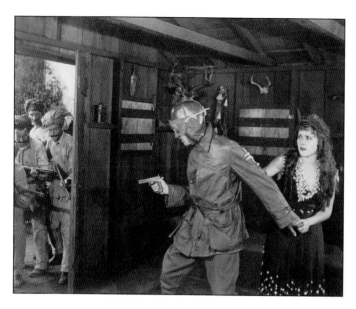

**SAVING THE STAR OF *RUTH OF THE ROCKIES*.** Ruth Roland, the glamorous action star, is pictured on the right wearing an elaborately adorned costume. Roland excelled at saving herself from crashes, cliff jumps, blades, and endless disasters; therefore, so this scene shows a depth of confidence in her aviator savior. This 1920 Pathé Roland production is about a young woman (Roland) who finds a trunk full of stolen diamonds and is subsequently pursued by the thief. (Shawna Kelly.)

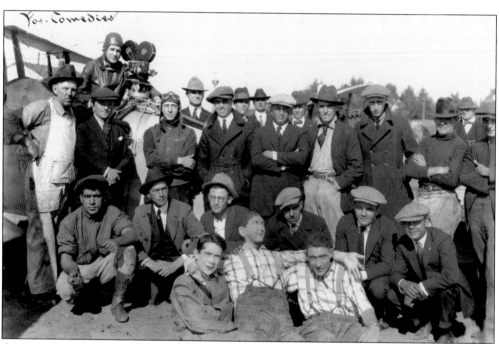

**CAST OF *THE BABY*, A FOX "SUNSHINE COMEDY," 1921.** Leading actor Ernie Adams (front left) poses with his stunt double (front right) and dummy, all lined up like triplets. Surprisingly, one of Daredevil DeLay's (aviator, standing to the right of the camera) most dangerous aerials involved a dummy drop into an automobile racing up a rocky road. High-altitude flying with no emergency landing spot within miles while maneuvering the cumbersome dummy within just feet above the racer was a hazardous endeavor. The dummy repeatedly yanked his airplane into the racer, flirting with a disastrous wipeout. (Shawna Kelly, DeLay Heritage Collection.)

**BIG BOY WILLIAMS, WILL ROGERS JR., AND DAREDEVIL DELAY.** Hollywood aviator B. H. DeLay is piloting in the second cockpit. Guinn Williams was nicknamed Big Boy since he was very tall and muscular from years of working on ranches and playing professional baseball. Rogers Jr. had a long career in acting and then became a well-regarded Southern California politician. Williams's father was also a political representative. Will Rogers Sr. was one of the most celebrated characters in the entertainment business. (Shawna Kelly, DeLay Heritage Collection.)

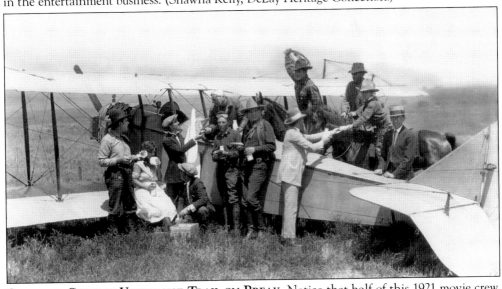

**CAST AND CREW OF VENGEANCE TRAIL ON BREAK.** Notice that half of this 1921 movie crew, surrounding B. H. DeLay's airplane, is acting theatrically while the other half is candidly serene. DeLay (aviator leaning over the cockpit) performed, often live, with Western stars such as Tom Mix, Buck Jones, William S. Hart, Hoot Gibson, Harry Carey, and swashbuckler Douglas Fairbanks. (Shawna Kelly, DeLay Heritage Collection.)

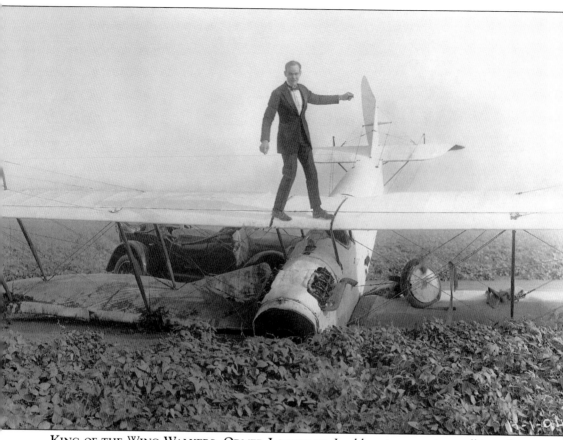

**KING OF THE WING WALKERS, ORMER LOCKLEAR.** Locklear is seen wing walking after an airplane-automobile collision in 1920 during the making of Fox's *The Skywayman*. Locklear was the first wing walker and was one of the most successful star aviators. He was sent on a two-month national tour by Universal's president Carl Laemmle to promote *The Great Air Robbery*. On August 2, 1920, Locklear and Milton "Skeets" Elliott performed the final aerial sequence for *The Skywayman*, a night dive 5,000 feet above DeMille Airfield No. 2. Wing flares were set to create the effect of an airplane on fire. Locklear had instructed the director to kill the searchlights illuminating their spiraling dive to signal when to pull out. The blinding lights were not cut, and the airplane exploded into a fireball among oil derricks on DeMille Airfield. Locklear's close companion, actor Viola Dana, went into shock watching it unfold. The pageantry of his funeral rivaled Rudolph Valentino's. The Goodyear Pony Blimp followed Locklear's hearse, while six of Daredevil DeLay's airplanes were in an aerial procession dropping roses. Hollywood studios emptied to join Locklear's procession. (Marc Wanamaker, Bison Archives.)

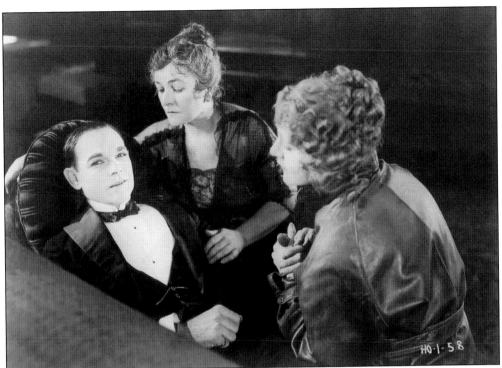

**ORMER LOCKLEAR STARRING IN *THE SKYWAYMAN*.** Costar Louise Lovely (right) comforts Locklear in his recovery scene. The leading Hollywood pilots had many near-death crashes, both intentional and unintentional, under their belt. This film retains the real-life final crash footage of Locklear. He had just founded his own movie studio and was rising to superstardom before that dramatic and fateful night at DeMille Airfield. (Shawna Kelly.)

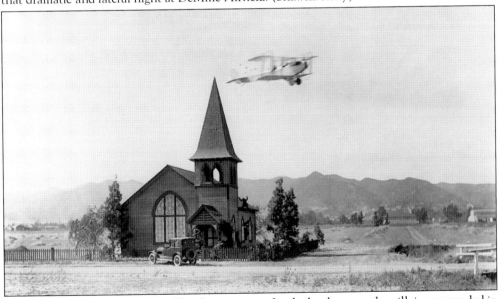

**ORMER LOCKLEAR AERIAL FOR *THE SKYWAYMAN*.** Look closely to see the villains suspended in midair who Locklear's aerial stunting knocked off of the tower to the right. (Marc Wanamaker, Bison Archives.)

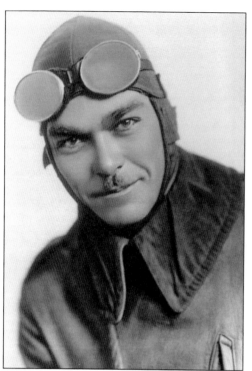

**AVIATOR STAR ORMER LOCKLEAR.**
Locklear was one of the most successful star aviators, and he shined in *The Great Air Robbery*. In 1919, with a $250,000 budget (over $3 million today), Universal's rising investment reflected the studio's statement, "The sky's the limit" with this air thriller production. Locklear performed his airplane-to-airplane transfer, as well as an airplane to a speeding car transfer, and then a transfer back again just before the car turbulently crashed. (Art Ronnie.)

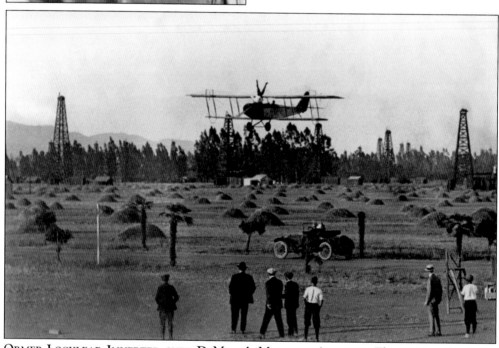

**ORMER LOCKLEAR INVERTED OVER DEMILLE'S MERCURY AIRFIELD.** This 1920 performance foreshadows Locklear's fateful death dive on DeMille's airfield during *The Skywayman*. Locklear also flew Buster Keaton upside down at 5,000 feet above Hollywood. The premier aerial exhibitionist and first aviator to cross the Pacific nonstop, Clyde Pangborn was often inverted with his aircraft and known as "Upside Down" Pangborn. (Shawna Kelly, DeLay Heritage Collection.)

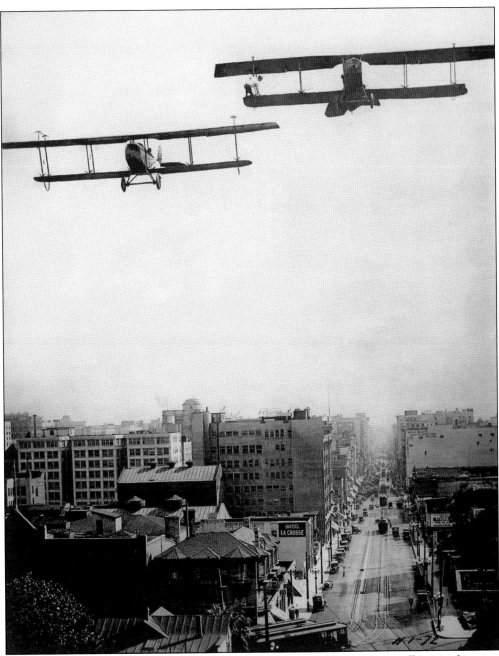

**CITYSCAPE AIRPLANE-TO-AIRPLANE TRANSFER.** Ormer Locklear is wing walking in this view shot from Hill Street in Los Angeles. Locklear also landed on top of San Francisco's St. Francis Hotel for *The Skywayman*. Furthermore, he performed the "dance of death," which is when planes overlap while the pilots transfer airplanes in midair with no one piloting. Communities across the nation held Locklear Days events. He was also a featured performer for children's benefit exhibitions in major cities such as Los Angeles and San Francisco. (Marc Wanamaker, Bison Archives.)

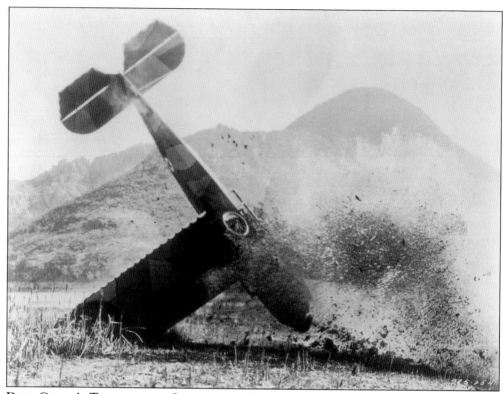

**DICK GRACE'S TUMULTUOUS CONTROLLED CRASH FOR *YOUNG EAGLES*.** Grace's precision crash for this Paramount film was performed in 1930. Ironically, Grace specialized in the most dangerous controlled crashes, yet he outlived most of the leading Hollywood aviators. During his lengthy career, which spanned from the 1920s to the 1960s, Grace performed nearly 50 crashes and broke about 80 bones. (Art Ronnie.)

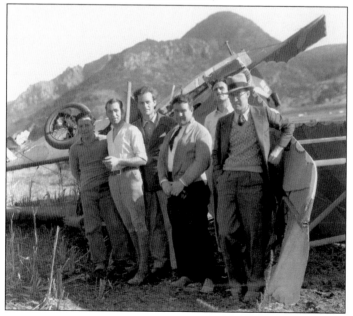

**HOLLYWOOD AVIATOR DICK GRACE AND A "CRACK UP" (CRASH) FOR *WINGS*.** Grace (second from left) is seen with combat aviator veteran director William A. Wellman (third from left). This SPAD A.VII was crashed by Grace for the great air epic *Wings*. Grace noted, "The poor little ship was dead. There was not a spar or rib in it that was not broken." Grace immortalized his reputation by performing four major crashes for *Wings*. (Marc Wanamaker, Bison Archives.)

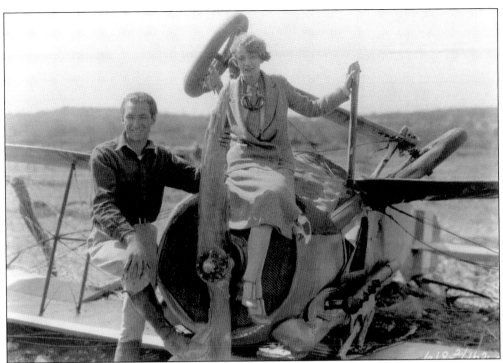

CRASH KING DICK GRACE AND HIS "CRACKED UP" MASTERPIECE FOR WINGS. While Grace was in the early stages of recovery from a broken neck sustained crashing for *Wings*, he jumped out of the window of his second-story hospital room to visit his girlfriend. Grace revealed that his slight paralysis on the right side of his face "shocked her into the arms of another," and the next day she became engaged to another man. This is especially ironic, since Grace outlived nearly all of the Hollywood aviators. (John Underwood and Phillip Dockter.)

GRACE EXTREME CRASH FOR YOUNG EAGLES IN 1930. A prop wash–obscured bush in the foreground conceals a hidden microphone to capture the spectacular crash sound effects. Grace's average crash speed was over 100 miles per hour, and he believed that his crashes had to be performed at 11:45 a.m. in order to be successful. (Marc Wanamaker, Bison Archives.)

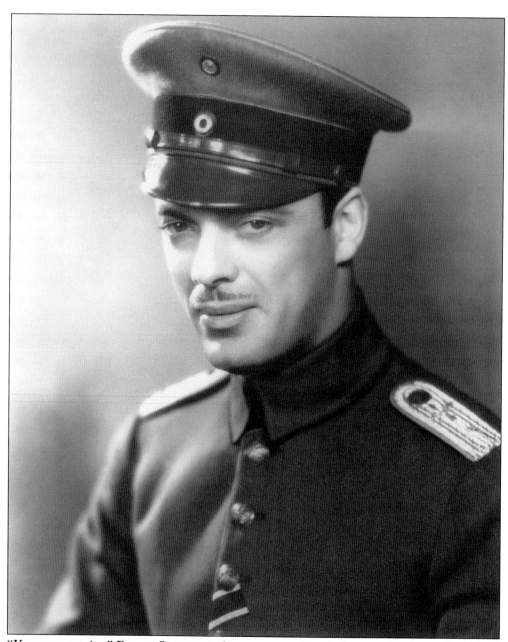

**"KING OF THE AIR" FRANK CLARKE IN COSTUME FOR *HELL'S ANGELS*.** Clarke performed the role of Lieutenant von Bruen and was also the chief pilot in charge of *Hell's Angels* aviators. "Handsome Clarke had more women crazy for him than the picture's leading man." A Hollywood columnist of the period also called him "satanically good looking." Clarke was also known as "Spook." Many stories are behind this moniker of the fearless aviator. Part Irish and Cherokee, Clarke grew up on a ranch in California. Rather than becoming a rodeo cowboy, Clarke learned to fly from the "Grand Old Man" of motion picture pilots, Al Wilson from Venice Airfield. Clarke's dashing romantic escapades included flying his airplane up the side of a hotel to toss a love letter connected to a rock through his romantic interest's window. (John Underwood and Phillip Dockter.)

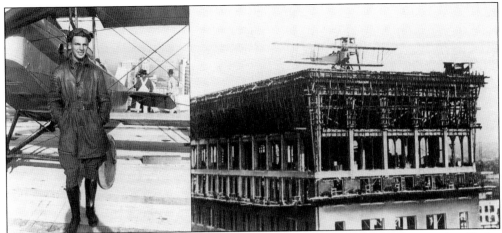

**FRANK CLARKE RIGHT BEFORE INFAMOUSLY FLYING OFF.** During filming of *Stranger than Fiction* in 1921, Clarke fearlessly flew his Canuck Jenny off the roof of the Los Angeles Railway Building. Clarke was prohibited from landing or taking off, so his airplane was disassembled and hauled to the top of the ten-story building. The Goodyear Blimp was filming when pilot Wally Timm cut the tethering rope that suddenly released Clarke's airplane. Clarke roared off from the short 100-foot-long roof. He dipped several stories, yet swooshed up just in the nick of time. The crowds below cheered. He was arrested when landing at Chaplin Aerodrome, but clever Clarke talked his way out of any charges. (Art Ronnie.)

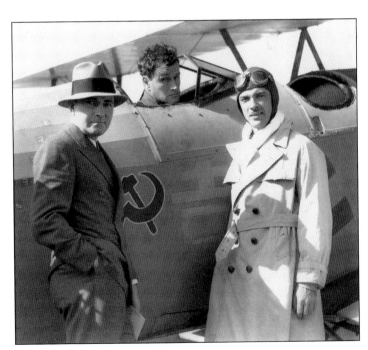

**WILLIAM A. WELLMAN, RICHARD BARTHELMESS, AND FRANK CLARKE.** Barthelmess, at left, starred in the first *Dawn Patrol*. Wellman, in the cockpit, directed *Wings* and held the aviators in the highest esteem out of anyone in the motion picture field. Leading Hollywood aviator Clarke is on the right. (Marc Wanamaker, Bison Archives.)

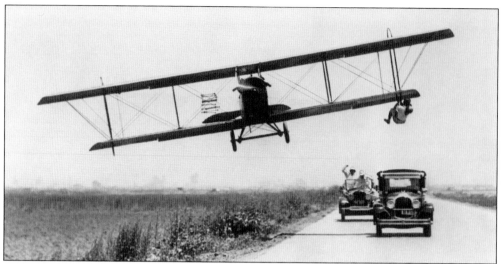

**AL WILSON IN HIS AIR THRILLER *THREE MILES UP.*** In this 1927 filming, Wilson hangs on the wing while pilot Frank Tomick hits the throttle. In *Won in the Clouds*, Wilson acts out a spectacular fistfight scene on the wings of an airplane. Wilson's airplane-mounted camera once ripped off during filming in midair, causing fuel to dump over the engine, which caught on fire. He was without a parachute and successfully landed while engulfed in flames. (Art Ronnie.)

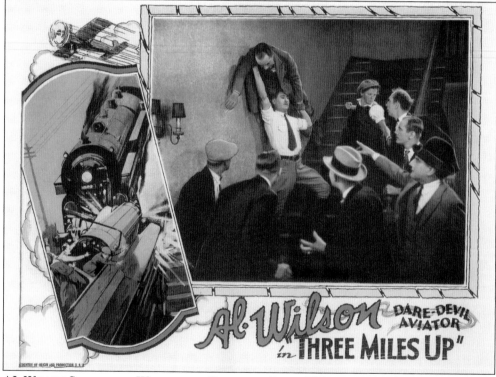

**AL WILSON STARRED IN, WROTE, AND PRODUCED FILMS.** Wilson was also the DeMille Airfield manager during the filming of many noteworthy air thrillers. Wilson's films were heavily loaded with aviation themes, as was this 1927 film, *Three Miles Up*. The Jenny aerials were performed by Wilson, Art Goebel, and Frank Tomick. (Amélie Archives.)

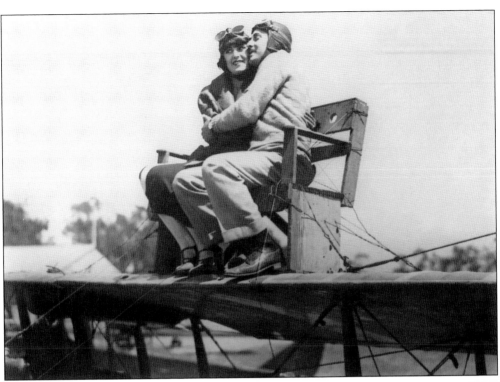

**AL WILSON AND VIRGINIA FAIRE.**
This scene was captured during
the making of *Air Hawk* in 1924.
Between earlier films in 1920, Wilson
barnstormed large expositions in
Chicago and throughout the Midwest,
finishing in Virginia. "Hopping"
passengers usually paid $1 a minute
for five minutes in the air, which
would total roughly $60 at the
present time. (Shawna Kelly, DeLay
Heritage Collection.)

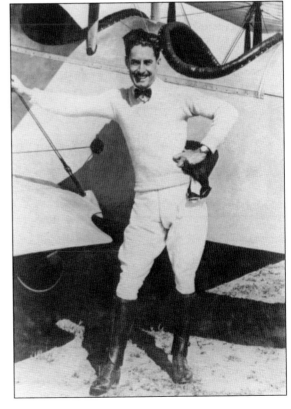

**AL WILSON AT DELAY AIRFIELD IN
1920.** Daring and dashing, Wilson
was considered the first professional
motion picture aviator and was the
leading star in a number of motion
pictures. He taught legendary director
Cecil B. DeMille to fly at DeLay
Airfield. (Amélie Archives.)

**"Snooky" [Anita Snook] and Paul Mantz, Teacher and Technical Advisor for Amelia Earhart .** High-achieving Hollywood aviator Paul Mantz (far right) advised many of the technical details of Earhart's record accomplishments. Snook (left) was the first woman to run a commercial airfield and taught Earhart to fly. Earhart also bought an Airster, dubbed *The Canary*, from Snooky's Kinner Airfield. Snooky and Earhart became good friends, as did Mantz and Earhart. (John Underwood and Phillip Dockter.)

**Pancho Barnes: "Speed Queen" and a Living Legend.** Affectionately referred to as simply Pancho, she was a speed racer who could out-fly Amelia Earhart. In 1930, she broke the speed record at 196 miles per hour in her Travel Air at Van Nuys Airport. Pancho also founded the Women's Air Reserve (WAR). She was known as the "Mother of Edwards Air Force Base," and her grandfather Thaddeus Lowe was the "Father of the Air Force" as an aeronaut. (John Underwood and Phillip Dockter.)

**"MISS AMERICA OF THE AIR" RUTH ELDER DURING MORAN OF THE MARINES, 1928.** A Ninety-Nine aviatrix, Elder costarred in this film with Richard Dix. She also raced in the famed first Women's Air Derby of 1929. Elder nearly beat Amelia Earhart to the famous solo Atlantic crossing record, but her engine failed after nine hours, landing her in the ocean only a couple hundred miles from the finish. Elder was retrieved and celebrated with a ticker-tape parade for her courageous flight. Elder often endured crushing crowds of fans flocking around her. (Marc Wanamaker, Bison Archives.)

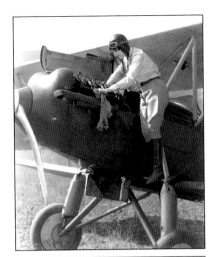

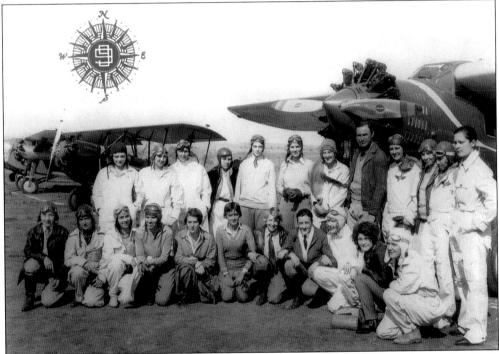

**NINETY-NINES WITH HOLLYWOOD AVIATOR ART GOEBEL.** This image was taken at the May 9, 1930, opening of Margaret Perry's airport in Culver City. Amelia Earhart (not pictured) was the first president of the Ninety-Nines, and Perry became the second president of the organization. Many in this image were founding members of the Ninety-Nines, which formed following the famed First Women's Air Derby of 1929. The purpose of their organization was to have "good fellowship, jobs, and a central office and files on women in aviation." From left to right are (kneeling) Peggy Gillihan, Ethel Richardson, Melba Gorby (Beard), Ruth Alexander, Felicia Farrow, Katherine Ince, Elizabeth Kelley, Evelyn "Bobbi" Trout, Marjorie Crawford, Aileen Miller, and Patty Willis; (standing) Peggy Paxon, Edith Magalis Foltz (Stearns), Eileen Curly, Mrs. Helen Simpson, Lindsay Holliday, Edith Bond, Margaret Perry (Cooper Manser), Art Goebel, Mary Billie Quinn, Nora Alma White, Jeanne Davies, and Lady Mary Heath (Williams). The Ninety-Nines have grown to be internationally active. (Jeannine Dixon Seely, Patty Willis family collection.)

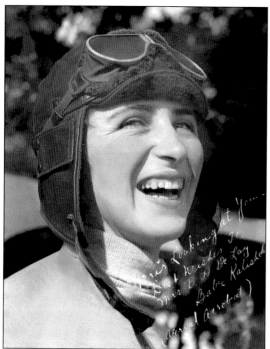

**"BABE" KALISHEK.** She was most known solely as Babe, her professional performance name. She would fly solo or join forces with performers such as Gladys Ingle and the 13 Black Cats to wing walk while flying under bridges and dazzle audiences with other fantastic feats. Babe was an advanced wing walker who also performed athletic acrobatics in the air, so she was elegantly referred to as an aerial acrobat. (Shawna Kelly, DeLay Heritage Collection.)

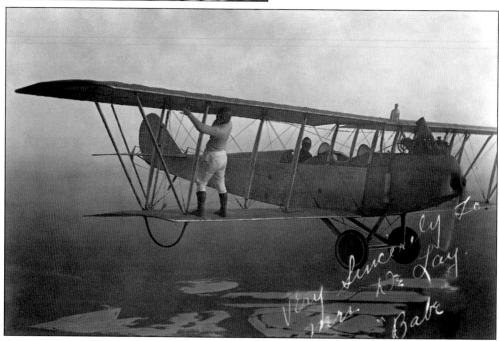

**AERIALIST BABE KALISHEK IN ACTION.** An aviatrix with acrobatic finesse, Babe was also known to shock crowds with sudden trick falls off the wings of airplanes that held hidden parachutes. Rival actor aviatrix Andrée Peyre's aerials pushed the limits so fiercely, no one would rent Peyre a stunt airplane for a Ruth Roland production, but that did not ground her. Peyre met the challenge by purchasing her own airplane in order to perform aerials for the 1923 thriller *Ruth of the Range*. (Shawna Kelly, DeLay Heritage Collection.)

**HARRIET QUIMBY IN A SPECIALLY DESIGNED COSTUME.** Quimby was the first woman to earn a pilot license in the United States on August 1, 1911. She was also the first woman to fly across the English Channel. Though Quimby acted in character roles, she excelled more as a screenwriter for D. W. Griffith. The image of Quimby in her Blériot (left) was captured right before her channel record. The good luck amulet she is wearing mysteriously disappeared in her final flight. Quimby performed in exhibitions with Matilde Moisant, the second licensed aviatrix. Moisant named her airplane *Lucky 13* and earned her pilot's license on August 13, 1911. It is ironic that Moisant flaunted superstition in her flying career, and yet the more cautious Quimby fatally crashed during a 1912 exhibition. (Giacinta Bradley Koontz.)

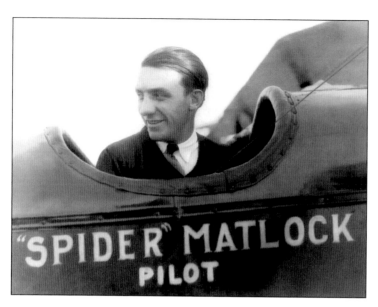

**"SPIDER" MATLOCK, ONE OF THE ORIGINAL 13 BLACK CATS.** Wing walker William "Spider" Matlock was one of the founders of the 13 Black Cats, the earliest well-known organization of Hollywood aviators that set rate and aerial standards for the movie industry. The group was based at Burdette Airfield and many of its standards evolved from DeLay's company at the Venice airfield. (Shawna Kelly.)

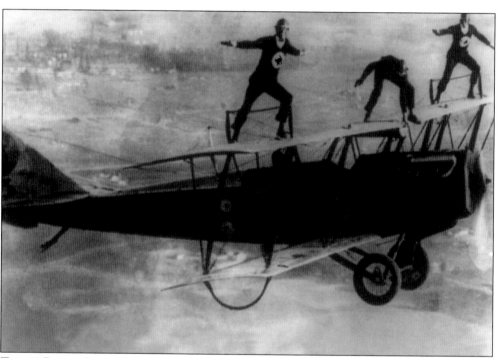

**THE 13 BLACK CATS WING WALKING.** Members of the 13 Black Cats defied both superstition and death in their performances for newsreels and motion pictures. Al "Black Cat" Johnson amazingly overcame the threat of death during filming by holding the airship's landing gear wheel together with his own body since a one-wheel landing was usually a crash certainty. He held the ill-fitting replacement wheel in place—with his own feet—during the landing, which turned out to be an incredible success. The 13 Black Cats repeated "save the day" incidents like this for newsreels. (The Hatfield Collection/The Museum of Flight.)

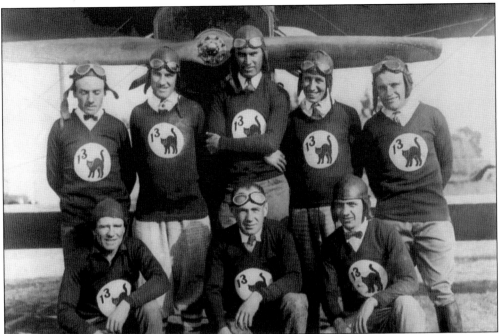

**THE 13 BLACK CATS ORGANIZATION.** The unity of the organization enabled pilots to elevate safety, creative control, and compensation in motion pictures. Pictured from left to right are (kneeling) Herb McClelland, Sam Greenwald, and Spider Matlock; (standing) Al Johnson, "Bon" MacDougall, Art Goebel, "Fronty" Nichols, and Paul Richter. Members missing from the image are Gladys Ingle, Reginald Denny, Freddy Osborne, Ivan Unger, Jerry Phillips, George "Slim" Maves, "Loot" Barber, and Howard Batt. Their logo originated from the black cat insignia on MacDougall's airplane. (The Hatfield Collection/The Museum of Flight.)

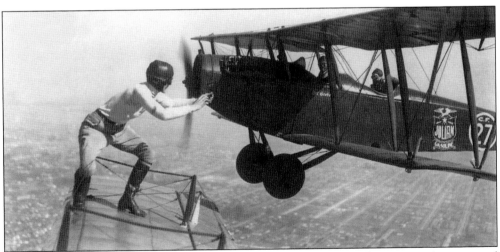

**GLADYS INGLE OF THE 13 BLACK CATS.** Ingle was the first to perform target shooting and archery on an airplane. She also completed over 300 airplane transfers without a parachute. Thrilling footage of Ingle attaching a new tire in flight is still viewed with tremendous awe. (Amélie Archives.)

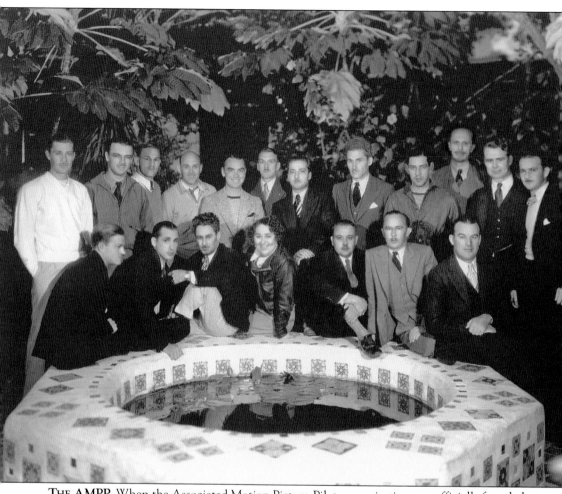

**THE AMPP.** When the Associated Motion Picture Pilots organization was officially founded on January 4, 1932, it locked in virtually complete control of motion picture aviation. Pictured around Pancho's Fountain from left to right are (seated) Earl Gordon, Dick Grace, Al Wilson, Pancho Barnes, Tave Wilson, Dick Rinaldi, and Joe Touhey (public relations representative); (standing) Earl Robinson, Frank Clarke, Garland Lincoln, Roy Wilson, Jack Rand, Howard Batt, Clinton Herberger, Oliver LeBoutillier, Ira Reed, and three union representatives. AMPP members not pictured are Leo Nomis and Frank Tomick. Nomis became the first AMPP president, followed by Frank Clarke. (Marc Wanamaker, Bison Archives.)

# *Three*

# ACTOR AVIATORS
## RISING ABOVE THE REST

Aviation played a role in the ascension of a number of superstars. Stan Laurel and Oliver Hardy roared through the sky in early aviation comedies and rose above numerous comedy duos over the decades. Star comedian Larry Semon directed stunt aerials and performed aerial scenes in his comedies for outrageous effects; Mack Sennett directed some of the earliest aviation films at Biograph, starring Mabel Normand. Superstar Charlie Chaplin graced the cover of aviation magazines and promoted Chaplin Aerodrome with clever publicity. Furthermore, the greatest legendary onscreen lover, Rudolph Valentino, took to the air at aviation school and was more daring than his seductive reputation reveals.

The thrilling synergism of acting and aviation combined soared from the earliest screen scenarios. Blanche Scott, the first woman to fly, was also an aviatrix actor. The first woman licensed to fly, Harriet Quimby, was also an actor and screenwriter for D. W. Griffith. When early actor and aviatrix Florence Seidell unintentionally crashed twice during filming, the studio vigorously rewrote the script to include her airplane crashes.

It seemed as if the sky had no limits to the great heights stars could reach. Mary Pickford, one of the most legendary superstars in Hollywood history, starred in one of the earliest aviation films with famed pioneering aviator Glenn Martin. Her actor brother, Jack Pickford, also became close friends with the superstar aviator Ormer Locklear. Harold Lloyd was presented with his aviator wings at Clover Field. Rival to Mary Pickford, Mary Miles Minter was a very proud long-term aviatrix. Many of "Thriller Queen" action star Ruth Roland's films contained aerial thrills. Cowboy stars who raised their status to higher elevations within aerial motion pictures included Hoot Gibson, Harry Carey, Tom Mix, Buck Jones, Will Rogers, and Will Rogers Jr.

Directors and producers who displayed great appreciation for Hollywood aviators were Jack Warner, Carl Laemmle, Thomas Ince, William Duncan, James Horne, and certainly William A. Wellman. Howard Hughes was both shooting precision aviation scenes and breaking aviation records himself. Wellman, Bert Hall, and John Monk Saunders served in actual aviation battles during World War I. Producer/director Victor Fleming scouted for his movie locations by airplane. Cecil B. DeMille was willing to leave Hollywood behind to fly for our country, but the war ended before DeMille could soar into the aerial battle theater.

**RUDOLPH VALENTINO TRANSITIONED INTO ACTING THROUGH AVIATION.** Valentino attended aviation school with actor Norman Kerry, who assisted Valentino in landing acting roles. Valentino's aviation prowess enabled him to be seriously considered for taking over a high-speed film crash designed for Dick Grace, the "crash king." Grace was chosen to be most suitable for the contract after all. Just imagine if Valentino had damaged his legendary lover's looks or screen abilities in a crash gone awry, such as with the common crash hazard of bursting into flames on impact. (Shawna Kelly.)

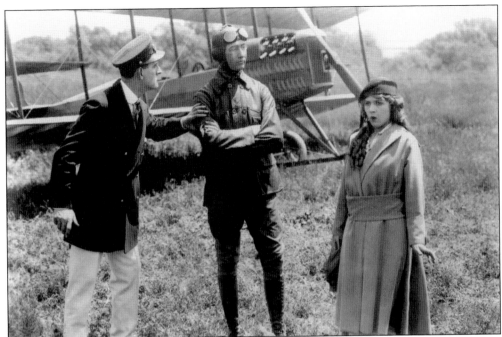

**MARY PICKFORD FILM WITH GLENN MARTIN.** Superstar Pickford is seen here performing in *A Girl of Yesterday* in 1915, which was filmed at North Island in San Diego and in Hollywood at Raleigh Studio. The other headliners were Pickford's brother Jack and world-famous pilot Martin (center). Martin's Model TT airplane is in the background. This Famous Players feature, directed by Allan Dwan, is regarded as the first to integrate U.S. military aviation. Martin, Lincoln Beachey, and Frank Stites performed the advanced aerials. (Marc Wanamaker, Bison Archives.)

**FLORENCE VIDOR, COMFORTING A DOWNED AVIATOR.** This scene is from the motion picture *Woman Wake Up* (1922). Hollywood aviators averaged several crashes under their belts. Therefore, this was an oft repeated emotionally charged scene for the pilots in real life. (Shawna Kelly.)

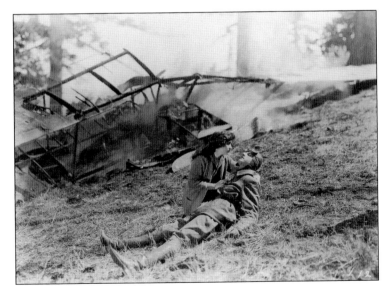

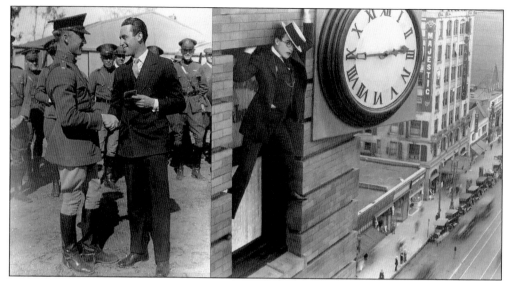

**HAROLD LLOYD PRESENTED WITH AVIATOR WINGS.** Lloyd was in the 477th Squadron of the Army Air Reserve. Lieutenant Giffin presents Lloyd's wings on November 11, 1925, at Clover Field in Santa Monica (now Santa Monica Airport). Lloyd is best known for his classic clock stunt scene (right) from *Safety Last!* (1923). (Shawna Kelly.)

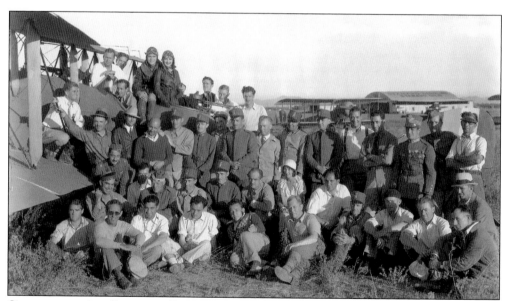

**COCK OF THE AIR CAST AND CREW IN 1932.** Billie Dove and Chester Morris starred in this film shot at Van Nuys Airport. Frank Clarke and Roy Wilson performed the aerial stunts. This Howard Hughes Caddo Company film survives, minus some code cuts deemed too sexy. (Marc Wanamaker, Bison Archives.)

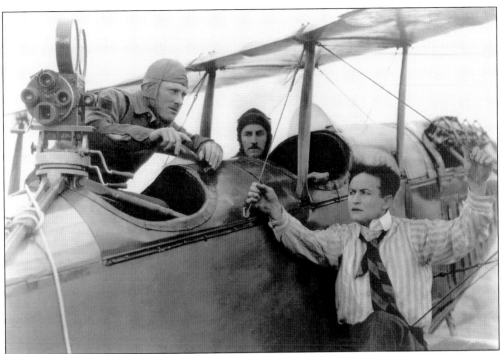

**HARRY HOUDINI IN *THE GRIM GAME* (1919).** Pictured from left to right are director and cinematographer Irvin Willat, Hollywood aviator Al Wilson, and actor/magician Harry Houdini (the first to officially fly over Australia). The script called for Houdini's character to hang by a rope between two airplanes. The awesome aerial sequences triggered overflowing theaters and massive popularity. (Amélie Archives.)

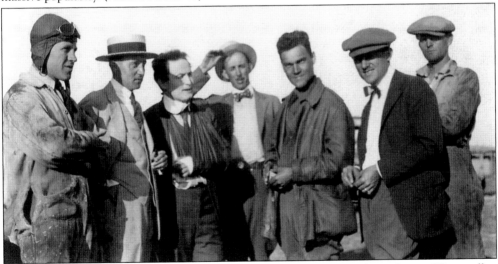

**HARRY HOUDINI, AERIALISTS, AND AVIATORS ON THE SET OF *THE GRIM GAME*.** Wing walker Robert E. Kennedy (far left) was doubling for Houdini when he was nearly chewed up by propellers before being slammed into the earth and dragged along the ground during the climactic crash landing, yet he magically survived. Kennedy was an instructor at March Field. The feature's astonishing aerials were also performed by David E. Thompson (third from right) and Christopher Pickup (second from right). (Marc Wanamaker, Bison Archives.)

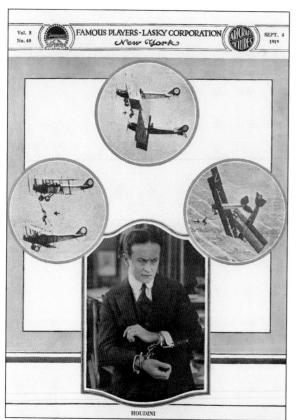

**HARRY HOUDINI'S *THE GRIM GAME* PUBLICITY.** Publicity heavily promoted the accidental, miraculous midair collision during the production of the Lasky-Paramount motion picture in 1919. *The Grim Game* had powerfully demonstrated the enormous popularity and potential of aerials in films. Notice aviator Kennedy suspended in midair during the nearly catastrophic collision sequence. (Marc Wanamaker, Bison Archives.)

**DUMMIES FROM *THE GRIM GAME*.** From left to right, Robert E. Kennedy, Ann Forrest, and Houdini pose with their magical dummies. Dummies do not land airplanes well in crash scenes but are desirable flight "fall guys" to drop on a rare occasion. (Marc Wanamaker, Bison Archives.)

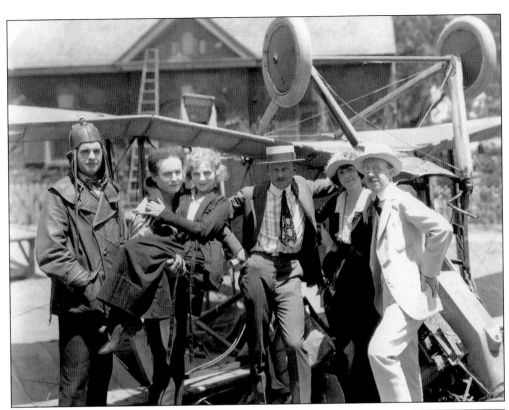

**CRASHED PLANE WITH THE CAST OF THE GRIM GAME (1919).** Houdini is holding Ann Forrest, the leading lady. Robert E. Kennedy is the aviator (left) who nearly perished performing the rope transfer from plane to plane during the forced crash landing. Crowds had to be turned away at theatres showing this critically acclaimed film. At the motion picture's climax, the villainous boss abducts Mary (played by Forrest) and flies away with her, and Houdini jumps into another airplane and takes off in hot pursuit. (Marc Wanamaker, Bison Archives.)

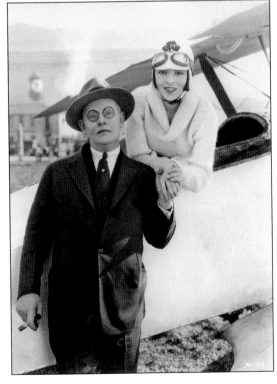

**FIRST NATIONAL STUDIOS PRESIDENT RICHARD ROWLAND AND COLEEN MOORE.** In March 1927, Moore (right) flew over the Burbank studio. Moore also exhibits the glamorous aviatrix look and verve present here in *Her Wild Oat*. Notice the special initialed emblem on Moore's leather helmet. (Marc Wanamaker, Bison Archives.)

**MARY PICKFORD PRESENTED GOGGLES.** Pickford, "America's Sweetheart," is presented goggles and an aviator cap by Clifford Henderson, the manager of the air races. Notice the wings on Pickford's jacket. The superstar was an avid promoter of aviation and was a spokesperson at the air races as well as president of the Women's International Association of Aeronautics (WIAA). She starred in one of the earliest aviation films, *Girl of Yesterday* (1915). She also owned her own Fairchild airplane and married aviator star Buddy Rogers. (Marc Wanamaker, Bison Archives.)

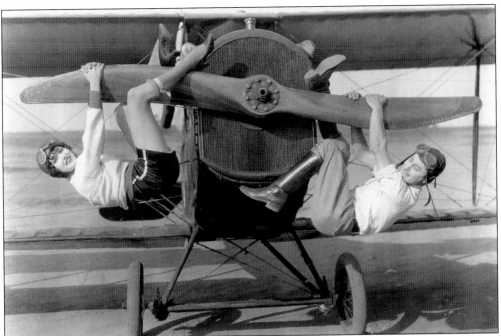

**AL WILSON AND ETHLYNE CLAIRE IN *THREE MILES UP*.** Filmed in 1927, Wilson portrays a former criminal who distinguishes himself as an air ace during World War I. Wilson's heroic flyboy character fakes his own death in a parachute accident and is nearly actually killed. He is nursed back to health by the daughter of a former army officer who greatly admires him. Wilson ultimately reaches his heroic potential. (Shawna Kelly.)

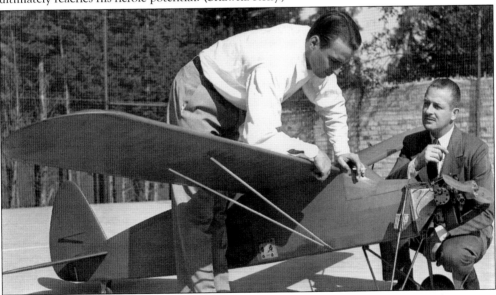

**REGINALD DENNY, A 13 BLACK CAT AVIATOR, WITH HIS RADIO-CONTROLLED AIRPLANE.** Denny's radio-controlled airplane business was where superstar Marilyn Monroe worked and was discovered by actor aviator Ben Lyon. This robot plane could fly to nearly 10,000 feet and was an invention for the antiaircraft unit of the army in 1938. Actor aviator Denny (left) is at the estate of millionaire sportsman Paul Whittier (right). (Marc Wanamaker, Bison Archives.)

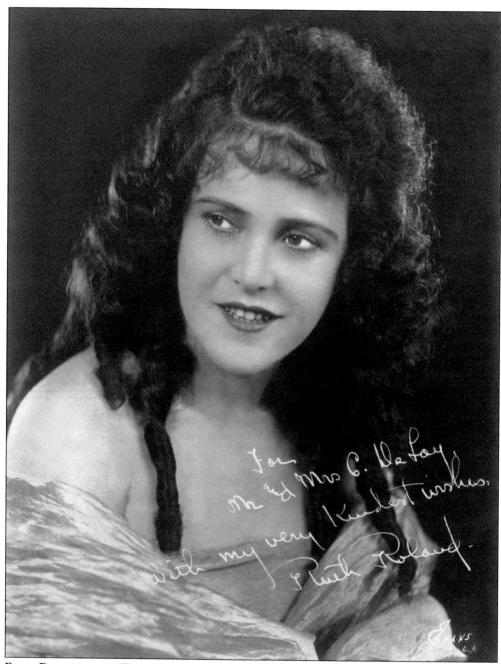

**RUTH ROLAND, THE "THRILLER QUEEN."** Roland was one of only two women ever to appear on the top-10 list of Western stars. She was born in San Francisco to a theater manager father and a professional singing mother and soon became a child star. Roland epitomized the American success story in multiple ways, investing her motion picture profits in real estate and becoming the richest star in Hollywood. She also largely influenced Hollywood through investing in theatres and acting schools, in which her actor husband Ben Bard coached leading stars such as Shirley Temple, Alan Ladd, Angie Dickinson, and vintage aircraft owner Cliff Robertson. (Shawna Kelly, DeLay Heritage Collection.)

**RUTH ROLAND IN AN ICONIC AERIAL POSE.** Roland performed the majority of her own stunts. She broke many bones and endured many incidents such as being kicked in the face during a fight scene. On the rarest of occasions her stunt double, Bobby Rose, took her place. Appearing stunningly silhouetted in the sky, Roland dangled from the bottom of planes, wing walked, and leaped out of many risky scenarios. (Marc Wanamaker, Bison Archives.)

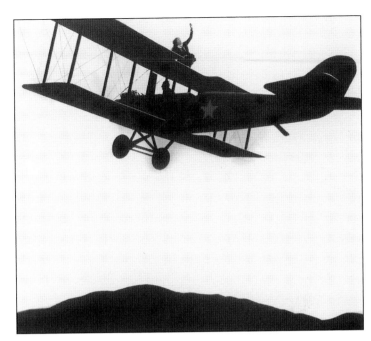

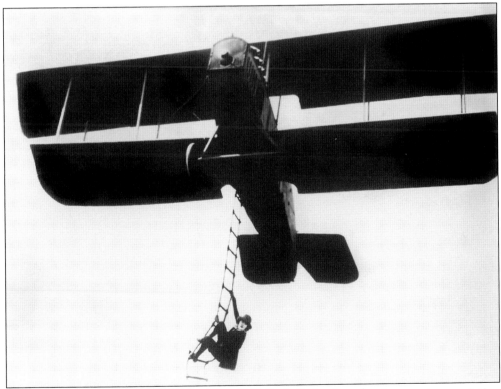

**RUTH ROLAND IN *TIMBER QUEEN*.** This 1922 Ruth Roland production was in association with Hal Roach Studio. The thrilling action of this motion picture is impressive in its breadth. Roland offered the complete package sought after in a star with her brains, beauty, and bravery. (Shawna Kelly.)

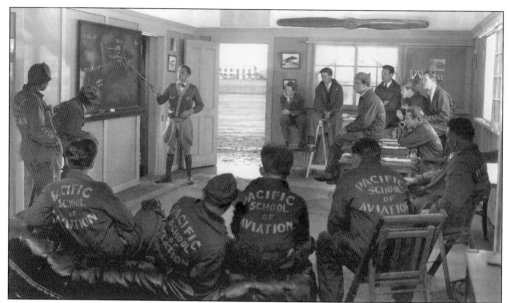

**PACIFIC SCHOOL OF AVIATION.** This is a scene from *Air Circus*, shot in 1928. The star headliners were Sue Carol as Sue Manning, Arthur Lake as Speed Doolittle, and David Rollins as Buddy Blake. It was directed by high-flying Howard Hawks at Clover Field in Santa Monica, California. Hawks was also a sport and military pilot. (Marc Wanamaker, Bison Archives.)

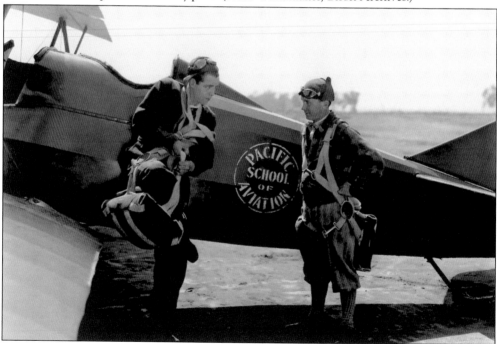

**AIR CIRCUS PARACHUTE SCENE FROM 1928.** Hollywood pilots avoided parachutes due to their deep loyalty to the aircraft owner and relentless pursuit of realism. This film's aerials were performed by Leo Nomis and Moye Stephens. The Pacific School of Aviation was located at Clover Field in Santa Monica (now Santa Monica Airport). This Fox production was a part-talkie film and believed lost, but it was rediscovered in the 1970s. (Marc Wanamaker, Bison Archives.)

**DOROTHY PHILLIPS CHRISTENED THE HAWK AT DELAY AIRFIELD.** Phillips was a prominent star of her day. Since it was the time of Prohibition, she smashed a "mysterious content . . . on the air limousine" propeller, the *Venice Vanguard* cleverly reported in 1921. The *Hawk* was built at DeLay Airfield. (Marc Wanamaker, Bison Archives.)

**CECIL DEMILLE'S SCREENWRITER JEANIE MACPHERSON, 1920.** Macpherson spent a significant amount of time with the aviators at the Hollywood airfields. She was an actor and a prolific screenwriter who lived a glamorous, racy life. She was a close companion of DeMille's for several years. (Marc Wanamaker, Bison Archives.)

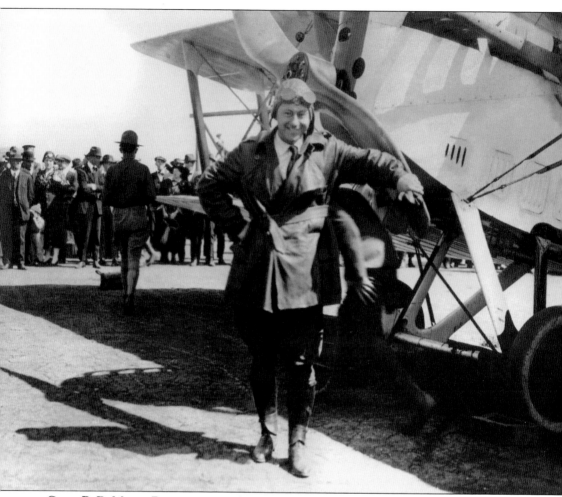

**CECIL B. DeMILLE, DIRECTOR AND AVIATOR.** DeMille was willing to leave Hollywood in order to fight for the United States as a pilot. He initially learned to fly at DeLay's Venice Airfield. World War I was over before his pilot service could be utilized. Studio executive Adolf Zukor was so nervous over DeMille's flying that he ordered him grounded during productions. DeMille delighted in flying multiple loops over Grauman's Chinese Theatre. In 1919, he opened Mercury Field No. 3 in Altadena, just north of Pasadena, California. DeMille operated the first regularly scheduled airline service to various destinations in Los Angeles, Bakersfield, Fresno, Venice, Long Beach, and Pasadena. DeMille's Mercury Aviation Company also landed a government airmail contract. Chaplin and DeMille Airfields operated on what is now the called the Miracle Mile, one of the most valuable regions of Los Angeles. (Marc Wanamaker, Bison Archives.)

**CECIL B. DEMILLE AND AL WILSON.** Wilson taught DeMille (left) to fly and managed his airfields. Notice the captivated youth looking on. DeMille purchased his first airplane from Venice Airfield. He declared the following in a 1939 interview about his aviation career: "No matter what it cost me, it was worth every cent. It was thrilling, adventuresome; satisfying." (Marc Wanamaker, Bison Archives.)

**CECIL B. DEMILLE AND JESSE L. LASKY.** Paramount producer Lasky's first flight was with DeMille (left) in 1919. When their engine stopped, Lasky was shocked, thinking that they were going to abruptly dive to their demise. DeMille cut the engine to allow Lasky to clearly hear him say that he was about to transition into stunting maneuvers. (Marc Wanamaker, Bison Archives.)

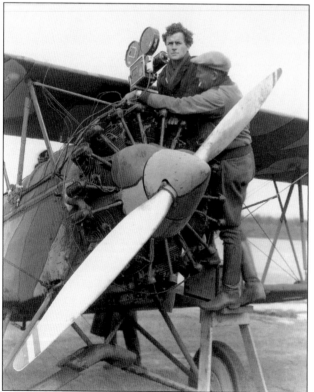

**WILLIAM A. WELLMAN DIRECTING *WINGS* IN 1927.** Aerial filming revolves around clouds, which are necessary as aerial backdrops in order for airplane speed and stunt sequences to exhibit visual scale and impact. (Marc Wanamaker, Bison Archives.)

**WILLIAM A. WELLMAN ADVANCING CINEMATOGRAPHY.** Wellman and leading aerial cinematographers advanced cinematography while shooting *Wings*, with innovations in mounts, automation, and more. Earlier, Al Wilson invented the first wind and snowstorm machine for motion pictures by mounting airplane propellers on automobile engines. (Marc Wanamaker, Bison Archives.)

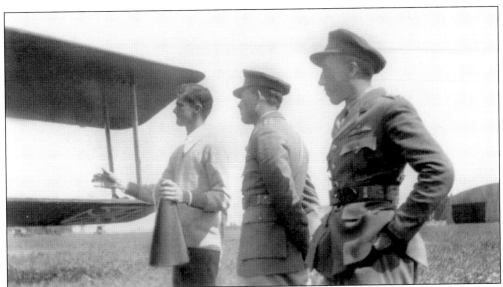

**HOWARD HUGHES PRODUCING *TWO ARABIAN KNIGHTS*, 1927.** Pictured from left to right are Howard Hughes, Roscoe Turner, and ace Patrick Fleming. This Hughes production is the one and only Academy Award winner for Best Direction of a Comedy Picture. It was thought to be lost for decades, but this film was recently rediscovered and restored with an orchestral score. (Marc Wanamaker, Bison Archives.)

**HOWARD HUGHES PRODUCING.** Howard Hughes (seated in producer's chair) was a record breaker as an aviator as well as in technical motion picture production, especially with *Hell's Angels*. The 2004 motion picture *The Aviator*, a biopic of Hughes life and times, won an astounding five Academy Awards and 45 international awards in total. (Marc Wanamaker, Bison Archives.)

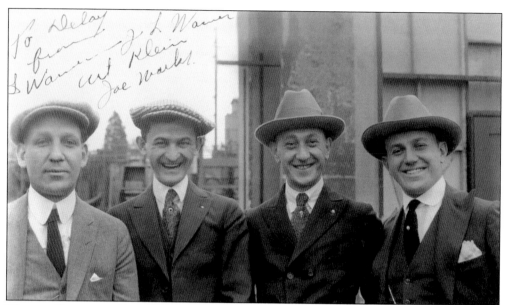

**WARNER BROTHERS.** From left to right, Sam Warner, Joe Marker (WB Studio Crew), Art Klein (WB Studio Cast), and Jack Warner pose during the making of *A Dangerous Adventure* in 1922. Jack Warner admired Daredevil DeLay's flying and became a flyer in the FMPU (First Motion Picture Unit) of the U.S. Army Air Force. Warner Brothers Corporation produced one of the most memorable aviation films in recent times, *The Aviator* (2004), directed by Martin Scorsese and starring Leonardo DeCaprio as Howard Hughes. (Shawna Kelly, DeLay Heritage Collection.)

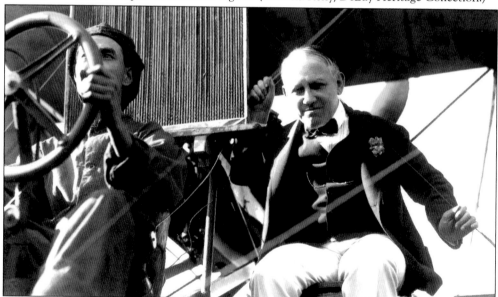

**CARL LAEMMLE FLOWN BY FRANK STITES AT THE OPENING OF UNIVERSAL CITY.** Laemmle, affectionately known as "Uncle Carl," was the founder of Universal Pictures. He was the first studio executive to realize the sensational potential of aviators featured in motion pictures. Laemmle was a major backer of the most spectacular aviators, including two greats who went out in blazes of glory performing for Hollywood, Frank Stites and Ormer Locklear. (Marc Wanamaker, Bison Archives.)

# *Four*

# BARNSTORMING AND BREAKTHROUGHS
## EXHIBITIONS, AERIAL ANIMALS, AND NEWSREELS

In the golden age of Hollywood, Americans craved newsreels, the true-life news shorts preceding feature films. The actual first sound film, released six months before the *Jazz Singer*, was a newsreel of Charles Lindbergh's most famous flight in 1927. Lindbergh became the first international media celebrity. Hollywood aviators at DeLay Field earned a substantial supplemental income from "pushing the limits" while performing in newsreels between motion pictures.

Star aviators such as Ormer Locklear barnstormed between productions on publicity tours for motion pictures. Cowboy stars often performed onscreen and in live exhibitions with aviators. Teams of barnstormers formed air rodeos and circuses. Clyde Pangborn was the lead aviator of the longest-flying team, the Gates Flying Circus.

Though originally a Shakespearean term, "barnstormer" became synonymous with touring stunt pilots through dramatic promotion. Stunt pilots would "buzz" a town with low-flying aerials, thereby immediately rounding up an excited audience. They would then land at a local farm and negotiate to use the field as a runway before the heroic show roared away.

They would loop, barrel-roll, tail-spin, "ghost dive," wing walk, play sports, dance on wings, transfer from plane to plane in midair, and hang from every portion of their airplanes with every imaginable part of themselves—including their hair and teeth. They risked everything to put on progressively more thrilling shows. Paul Mantz iconically barnstormed through a building onscreen. The motion picture and live performing barnstormers became "knights in the sky."

The Roaring Twenties were literally roaring, since pilots flew with lions and wild animal mascots. Roscoe Turner broke records while flying with his lion Gilmore. An aviator chimpanzee also performed loop-the-loops with Daredevil DeLay. A horse atop an airplane may seem too outlandish to be real, yet Cecil B. DeMille actually flew a live Shetland pony in a biplane.

**PAUL MANTZ REDEFINING BARNSTORMING.** Mantz's performance for *Air Mail* in 1932 solidified the title of barnstormer for aviators forevermore. Flying through this barn-like hangar was particularly risky due to the slim margin of error space available and wild wind fluctuations. Mantz had one of the longest Hollywood aviator careers of all, but right when he was retiring he dramatically gave his life for the motion picture *Flight of the Phoenix* (1965). (Marc Wanamaker, Bison Archives.)

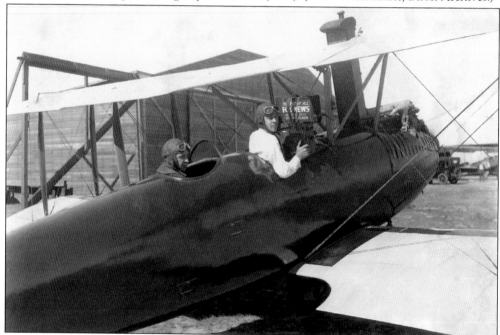

**FOX NEWSREEL AERIAL FILMING.** DeLay's motion picture aviator crew frequently performed new thrills for newsreels. Some of DeLay's pilots were newsreel cinematographers, such as Sam Greenwald who worked for Fox and then Hearst. Major newsreel companies of the 1920s were Fox Movietone, Warner-Pathe, Paramount, Universal, and Hearst Metrotone. (Amélie Archives.)

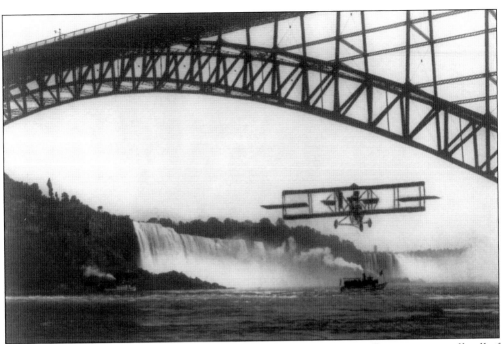

**LINCOLN BEACHEY DARING NIAGARA FALLS.** Beachey was a major influence to virtually all of the leading Hollywood aviators. He was the first pilot to loop-the-loops. About 30 million people saw the "Master Birdman" perform. In 1915, at the great Panama-Pacific International Exposition in San Francisco, he was flying upside down and looping for a crowd of 50,000 when the strain caused his wings to shear off, ending Beachey's lofty life. (Amélie Archives.)

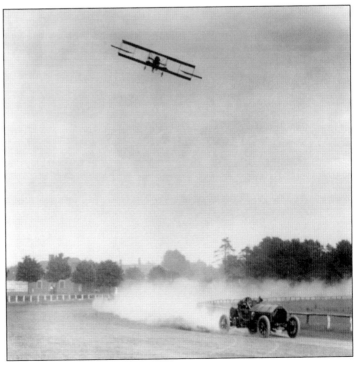

**LINCOLN BEACHEY RACING BARNEY OLDFIELD.** The "Demon of the Sky" went up against the "Daredevil of the Ground." Crowds flocked by the tens of thousands to see their daily competitions across the country. The racetracks where these exhibitions were performed included the Ascot, Portola, and Beverly Speedway. Cecil B. DeMille demonstrated this type of race in a Curtis Jenny at the Ascot Speedway with Eddie Hearne racing an Indianapolis Chevrolet. (Amélie Archives.)

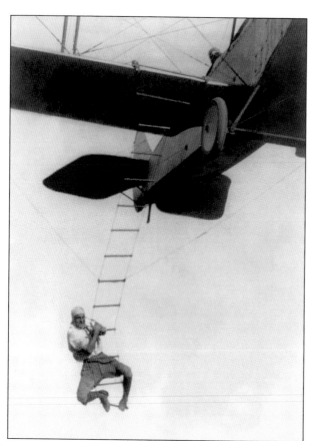

**"Fearless" Freddie Lund.** This motion picture stuntman is performing a classic aerial transfer. Lund was also an aerialist in the longest running exhibition aviator team, the Ivan Gates Flying Circus, led by "Upside-Down" Clyde Pangborn. (Amélie Archives.)

**DeLay Crew Train-to-Airplane Transfer.** DeLay is precision flying at March Field Air Base in Riverside, California. The train is speeding along during this perilous transfer from train to airplane. For this 1920 picture, DeLay spent a week in Riverside performing daring aerials. (Shawna Kelly, DeLay Heritage Collection.)

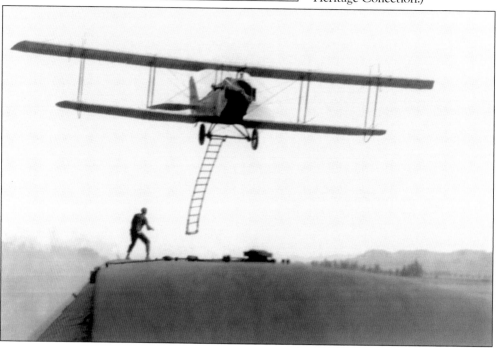

**AIRPLANE-TO-AUTOMOBILE TRANSFER.** Notice the many hazardous telephone lines surrounding this feat. Daredevil DeLay saved Lieutenant "Bob" Bartley, who ended up dangling right in front of the wheels of the car during filming. This happened on the popular motion picture drag Pico Boulevard near Venice. DeLay jerked the joystick just in time and the plane zoomed up while Bartley shot up the ladder into the cockpit. Bartley eventually successfully performed over 170 aerial transfers. (Marc Wanamaker, Bison Archives.)

**BOAT-TO-AIRPLANE TRANSFER.** Mabel Cody, Buffalo Bill Cody's niece, was the first woman to perform this splashy aerial transfer from a speeding boat onto an airplane in 1926. (Art Ronnie.)

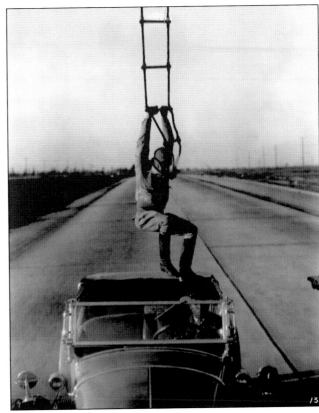

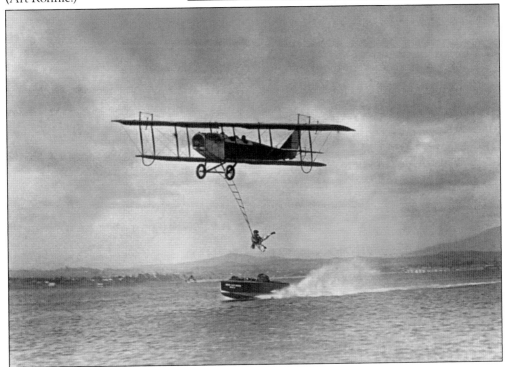

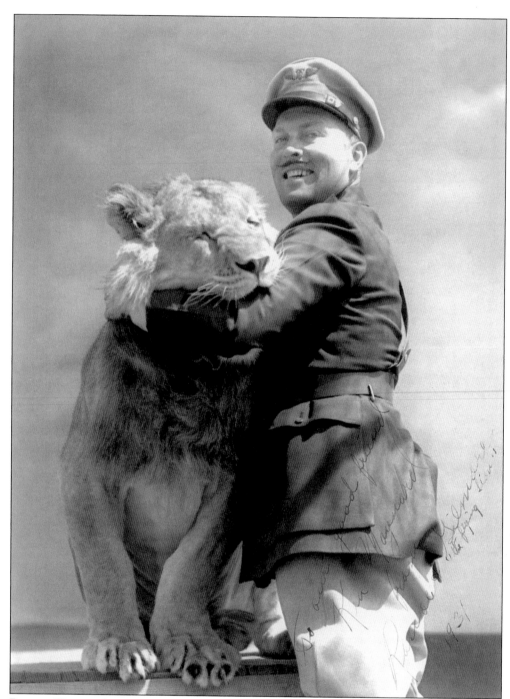

**Roscoe Turner Set Records with His Flying Feline, Gilmore.** Aviators have long been drawn to lion mascots. Gilmore flew with Turner since he was a cub. After Gilmore outgrew his cockpit, Turner was loyal to his lion partner and made sure he was fed the finest food for the rest of his life. Gilmore still exists today stuffed at the Smithsonian Air and Space Museum. "Speed King" Turner continued to win a record number of major race trophies. (John Underwood and Phillip Dockter.)

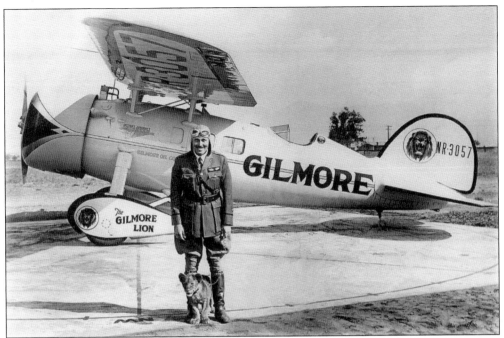

**FLYING LION GILMORE AND ROSCOE TURNER.** Gilmore was onboard when Turner set two transcontinental speed records in 1930. Then Turner broke another record by flying with Gilmore nonstop over three countries from Vancouver, Canada, to Agua Caliente, Mexico. Roscoe had also formed the Roscoe Turner Flying Circus. (John Underwood and Phillip Dockter.)

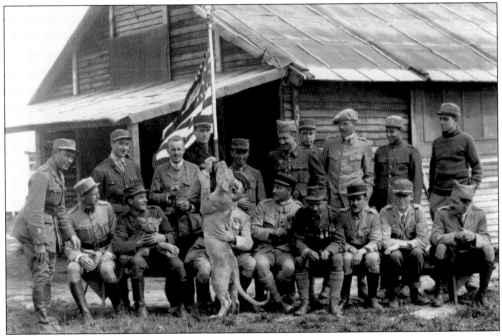

**LAFAYETTE ESCADRILLE WITH THEIR LIONS, WHISKEY AND SODA.** Adoption of lions as morale boosters has origins in the Lafayette Escadrille aviators of World War I and was recently portrayed in the 2006 movie *Flyboys*. (Amélie Archives.)

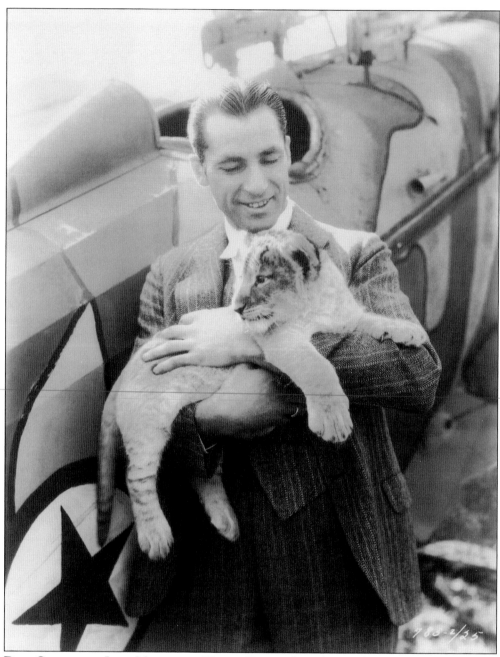

**DICK GRACE AND LION MASCOT OF *YOUNG EAGLES* (1930).** Daredevil pilots were drawn to felines as flying mascots. The lions symbolized limitless possibility and fierce determination. (Shawna Kelly.)

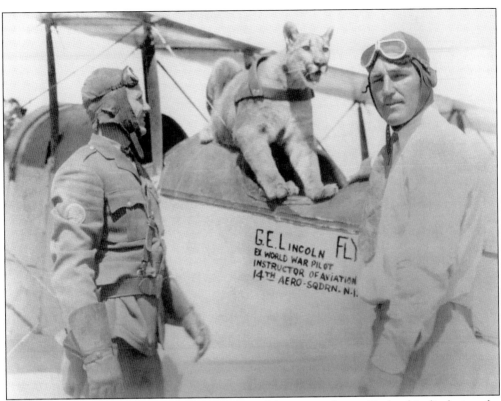

**AVIATOR LINCOLN GARLAND AND OSCAR THE MOUNTAIN LION.** Garland is displaying the courageous determination and cool composure of a daring pilot. Oscar was a 200-pound puma who usually rode around in public on the back of police officer Jack Tarkington's (left) Harley. (John Underwood and Phillip Dockter.)

**THRILLER QUEEN RUTH ROLAND WITH A LION.** Roland is displaying her natural daredevil charm. Roland was the Kalem Studio's featured "Kalem Girl" who was the subject of a 1912 documentary entitled *Ruth Roland, the Kalem Girl.* This showcase of stunting was filmed to display an action star's daring skills, including riding, diving, hunting, boxing, canoeing, and flying. Her limitless daring also led her to operate her own film production company, which shed founded in 1919. (Shawna Kelly.)

**JUMBO THE ELEPHANT, AL ST. JOHN, AND ART KLEIN.** Al St. John (left) was the scene-stealing actor and nephew of Roscoe "Fatty" Arbuckle. This shot was taken for publicity with Jumbo from the cast of the 1922 Warner Brothers film *A Dangerous Adventure* in 1922. (Shawna Kelly, DeLay Heritage Collection.)

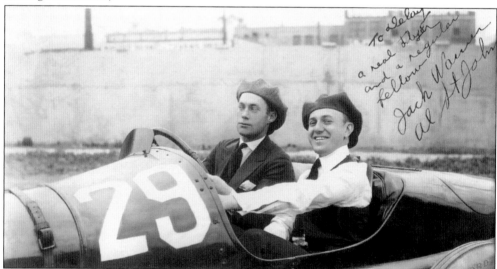

**JACK WARNER AND AL ST. JOHN.** Producer Jack Warner signed compliments on this photograph to actor aviator B. H. DeLay as "a real flyer and a regular fellow." Warner later became a flyer too as a lieutenant colonel in the FMPU (First Motion Picture Unit) at Fort Roach, which was Hal Roach's previous studio in Culver City. Producing 400 military aviation films, this was the first military unit formed entirely of motion picture personnel. Hollywood aviator Paul Mantz was an original member and colonel of the FMPU as well. (Shawna Kelly, DeLay Heritage Collection.)

**HOOT GIBSON AND HIS FLYING WIFE, SALLY EILERS.** The Hollywood aviators demonstrated a "code of honor" and loyalty similar to that of cowboys in the Wild West. Hoot flew his own aerial stunt scenes in *The Flyin' Cowboy* in 1928. He starred in aviation motion pictures, flew for sport, and was also involved in aviation businesses. (Shawna Kelly.)

**HARRY CAREY AND B. H. DELAY IN A WESTERN SCENE.** Universal star Carey is joining forces with his aviation action hero counterpart DeLay. Aviation and Westerns make a natural match. Both fields share values of posse/squadron loyalty, attire of jodhpurs/riding breeches, and terminology such as "bucking" airplanes. Aviators also "mounted" airplanes as if they were horses and performed in air rodeos together. Furthering this bond, Thomas Ince, the famous producer who previously owned DeLay's Venice Airfield, was the "Father of the Western motion picture." (Shawna Kelly, DeLay Heritage Collection.)

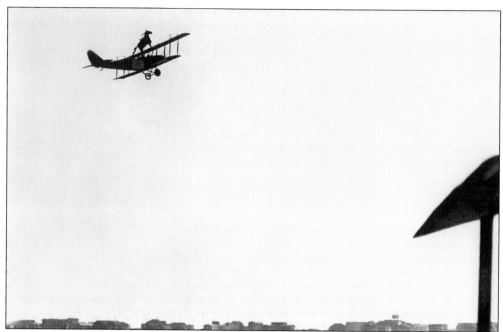

**IS THIS A REAL HORSE ON THE AIRPLANE OR NOT?** Most likely this was a model horse on the wings of DeLay's airplane for film shooting. From this camera angle, not much rigging gear is evident to prevent a real horse from spooking off of the airplane. Yet Cecil B. DeMille actually did fly a pony in a biplane to Santa Barbara. (Shawna Kelly, DeLay Heritage Collection.)

**MERCURY THE "PEGASUS PONY," DEMILLE'S MERCURY AIRFIELD.** Cecil B. DeMille's Mercury Aviation pioneered transport of animals such as goats and horses. These are views of the internal cockpit specially reinforced for Mercury's journey to Santa Barbara to compete in a horse show. This "Pegasus Pony" was carefully cushioned and checked for comfort by the SPCA. (Art Ronnie.)

**RUTH ROLAND ON HER HORSE JOKER.** Roland demonstrated her expert equestrienne abilities in a number of her films, including *Timber Queen* (1922). This daring actor's stunting expertise was so skillful that she could ride two horses standing with one foot on each back, avoiding being torn in two if they bolted apart. Roland could rise to virtually any action hero challenge from horse to airplane. (Marc Wanamaker, Bison Archives.)

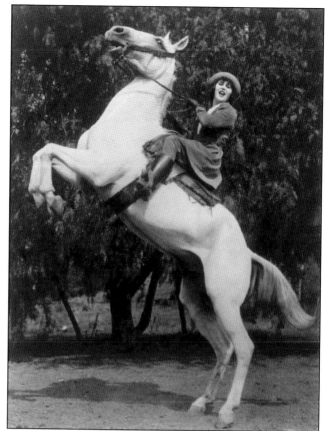

**AIRPLANE-TO-HORSE TRANSFER.** This aerial was innovated for motion pictures by the B. H. DeLay Company. DeLay's crew was also the first to perform the reverse aerial sequence of horse-to-airplane transfer. Stunt actor and cinematographer Cliff Bergere is transferring from horseback. (Marc Wanamaker, Bison Archives.)

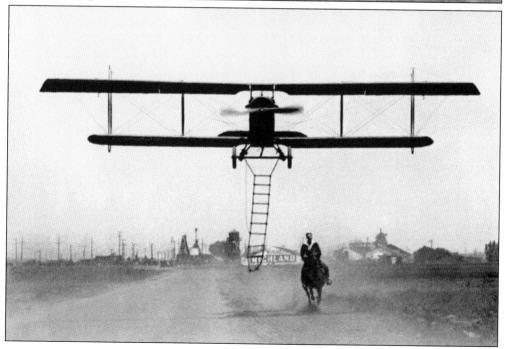

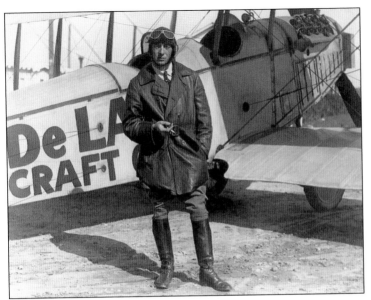

**B. H. DeLay at Chaplin Aerodrome.** Aviators from Chaplin, DeMille, and DeLay Airfields regularly joined forces for live and film performances. The *Venice Vanguard* reported that Chaplin and DeMille Airfields sent their "most daring flyers to augment the intrepid flyers" of DeLay Airfield for spectacular benefits in 1920. (Shawna Kelly, DeLay Heritage Collection.)

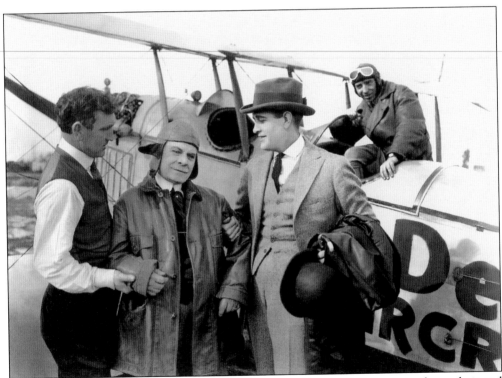

**Four-Time Los Angeles Mayor Meredith Snyder.** Daredevil DeLay is in the cockpit and from left to right are Donald Crisp, Mayor Snyder, and actor William Russell. Donald Crisp was voted as a "genuine thrill producer . . . and good luck champion of the entire world" by other celebrities at the races. (Shawna Kelly, DeLay Heritage Collection.)

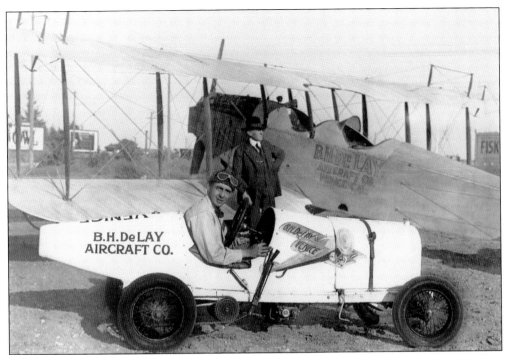

**DAREDEVIL DELAY WAS A RACER BEFORE A FLYER.** DeLay broke three ribs, both arms, a leg, a hip, a collarbone, and fractured his skull at a Portola race. The Mayo brothers patched him up excellently except for a slight leg limp. Hollywood aviators evolved from racing, engineering, military, stunting, equestrian, and rodeo backgrounds. Many of the leading motion picture aviators were inspired to perform by Lincoln Beachey. The most driven pilots headed for Hollywood aviator headquarters of DeLay Airfield. (Shawna Kelly, DeLay Heritage Collection.)

**DELAY FAMILY MEMBER, THE AVIATOR CHIMPANZEE.** This aviator chimp lived with the DeLay family for many years and performed loop-the-loops with internationally renowned pilot B. H. DeLay. The chimp had to go when he became too jealous of DeLay's daughters and attempted to throw daughter Beverley over the banister at their home. (Shawna Kelly, DeLay Heritage Collection.)

**B. H. DeLay Barnstorming Onscreen with Larry Semon.** This is the beginning of an explosive aerial sequence for the *Bell Hop* in 1921. These spectacular aerials escalated in the finale of the film. Actor, writer, and director Larry Semon was known to go over budget on elaborate special effects. (Marc Wanamaker, Bison Archives.)

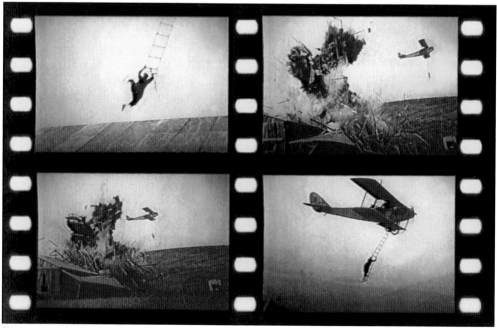

**Daredevil DeLay Performing Aerial Sequences with Comic Star Larry Semon.** This sequence displays DeLay's precision piloting of an explosive pickup aerial in the closing climax of *The Bell Hop*. If a motion picture pilot's timing is just slightly off with explosive timing, the results can easily be fatal. (Shawna Kelly, DeLay Heritage Collection.)

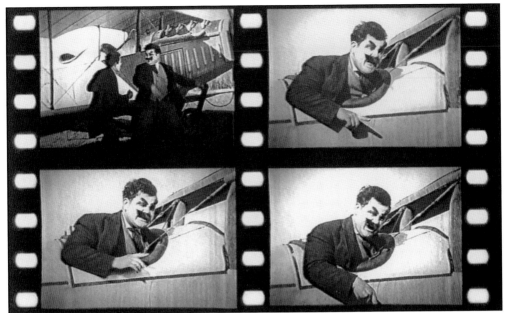

**DAREDEVIL DELAY AERIAL WITH OLIVER HARDY.** It is intriguing to see legendary Oliver Hardy with an oversized mustache playing the villain. Hardy was a codirector with Semon from 1921 to 1925. In *The Bell Hop* (1921), Hardy is credited as Babe Hardy. Daredevil DeLay performed the spectacular explosive aerials, in which at least one of his airplanes was completely demolished onscreen. (Shawna Kelly, DeLay Heritage Collection.)

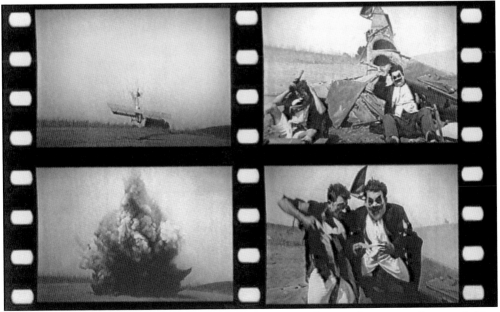

**GRAND FINALE AERIALS WITH OLIVER HARDY AND LARRY SEMON.** Semon was the comedy king of his day. He was known to often go over budget, since his stunt scenes were highly elaborate. DeLay's explosive pickup sequence and nosedive crash are still extraordinary by today's effects standards. (Shawna Kelly, DeLay Heritage Collection.)

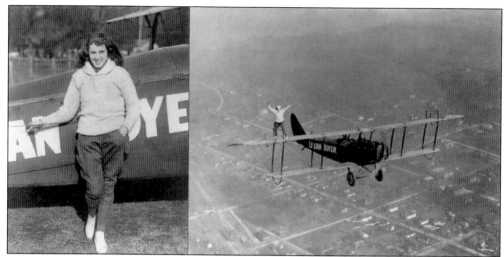

**AVIATRIX LILLIAN "EMPRESS OF THE AIR" BOYER.** Boyer performed in over 300 shows in over 40 states and Canada. Often wing walking throughout the 1920s, she performed over 100 automobile-to-airplane transfers and nearly 40 parachute jumps. Her Wild West counterpart and show rival, Mabel Cody, was the niece of world-famous Wild West showman Buffalo Bill Cody. The Mabel Cody Flying Circus performed night flying, airplane transfers without ladders, parachute drops, and wing walking while looping. (Amélie Archives.)

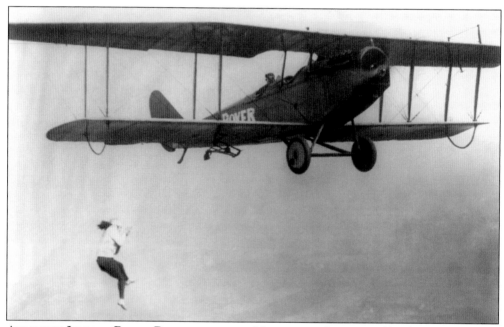

**AERIALIST LILLIAN BOYER PERFORMING FOR NEWSREELS.** Surviving film footage of Boyer's feats is breathtaking. Ethel "The Flying Witch" Dare performed equally impressive feats and was the first woman to transfer from airplane to airplane. Dare was also billed as "Queen of the Air" and specialized in the Iron Jaw Spin. Another fearless female aerialist was Gladys Roy, who wing walked blindfolded and danced the Charleston on the wing of her airplane. The first female parachutist was Georgia "Tiny" Broadwick, and in her expansive career she performed more than 1,000 jumps. (Amélie Archives.)

**LEGENDARY PANCHO BARNES WAS AN AVIATION ADVENTURER.** Barnes was a speed racer and organizer of the AMPP. She also operated the Happy Bottom Riding Club and opened her home to Hollywood aviators, generals, and other celebrities, many of whom became close confidants. An annual Edwards Air Force Base Pancho Barnes Day celebration occurs at the site of her club. The "Mother of Edwards Air Force Base" also founded the Women's Air Reserve (WAR). She is one of the most adventurous and multifaceted aviator characters in history. (John Underwood and Phillip Dockter.)

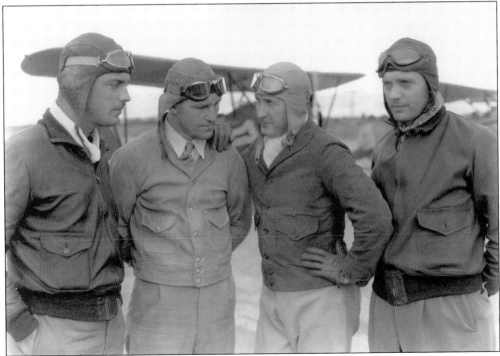

**HOLLYWOOD AVIATORS AND WESTERN STAR IN SPEEDWINGS.** Pictured from left to right are Frank Clarke, Lincoln Garland, Western star Tom McCoy, and Frank Tomick. This was shot during the filming of *Speedwings* in 1934 at Metropolitan Airport (Van Nuys). Most of the action unfolds in lively aerials including an airplane chase with a train. (John Underwood and Phillip Dockter.)

83

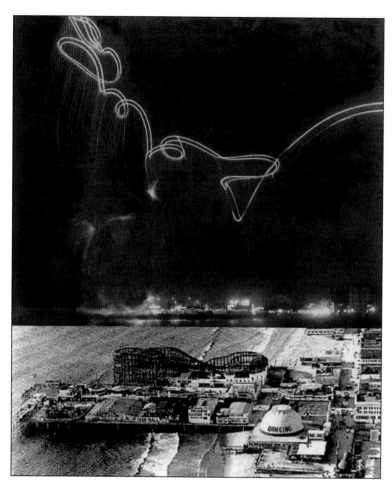

**DAREDEVIL DELAY PERFORMING THE "FIRE RIDE" OVER PICKERING PLEASURE PIER.** DeLay was driven to advance aviation performance with continuous feats such as proving that loop-the-loops could be performed at night. DeLay attached magnesium flares to his airplane and wrote his name (the *L* is inverted) in the sky. Twenty destroyers illuminated the horizon and his performance at a cost of $20,000, which is over $200,000 in current dollars. (Shawna Kelly, DeLay Heritage Collection.)

**FRANK STITES PERFORMING FOR THE OPENING OF UNIVERSAL CITY.** When Carl Laemmle opened Universal City in 1915, he flew with Stites and hired him to perform a staged bombing aerial at the opening ceremonies. Stites was knocked out of control by the shockwave of the ill-timed explosion of the airplane he was mock dogfighting. His "wings folded," as aviators say respectfully about fatal crashes. (Marc Wanamaker, Bison Archives.)

# Five

# ROARING ROMANCE
## HEROIC AVIATOR GLAMOUR

The Roaring Twenties set the scene for aerial romance as well as rapid record making and breaking. Charles Lindbergh, known as "Lucky Lindy," gained worldwide fame in 1927 as the first aviator to solo nonstop across the Atlantic Ocean. Actor Ruth Elder nearly landed the record first, but Amelia Earhart became the first woman to solo the Atlantic in 1928. One-eyed Wiley Post became the first aviator to solo around the world in 1931. Elder, Post, Earhart, and Lindbergh were all honored with ticker-tape parades, newsreel reports, or feature films made about them, and there was a great deal of overall fanfare.

Many of the foremost leading ladies fell for Hollywood aviators. Even Buster Keaton's offscreen leading lady, Viola Dana, soared into a rollicking romance of the air with star aviator Ormer Locklear. Dana and Locklear became the royal aerial power couple of the period. When Locklear visited Dana on a film set, he bounced his airplane wheels across the studio rooftops in the style of the "Beachey Bounce." Even the littlest leading lady, child star Shirley Temple, proclaimed her desire to marry her adult aviator costar, James Dunn. Paul Mantz operated the Honeymoon Express, which secretly flew stars to marry in Las Vegas, Nevada. Daring Earl Daugherty was married in the air. Numerous songs were written about the thrilling romance of the air, such as "Wait Till You Get Them Up in the Air Boys."

Viola Dana "buzzed" Hollywood Boulevard and threw her personal items out of her cockpit to the crowds cheering her on below. Daredevil DeLay was engaged by the Pantages motion picture palace for a racy publicity stunt to toss hosiery by the dozens out of his aircraft with the aid of their most ravishing actors. DeLay flew many glamorous characters, including princesses, stars, opera divas, and political figures. Hollywood's most celebrated attended the famous first fly-in only meet. Heroic aces, such as Charles Nungusser and Eddie Rickenbacker, enhanced the high-flying culture of Hollywood.

Race queens and kings ruled the glamorous airways of Hollywood lifestyle. The Ninety-Nines were both glamorous and fierce female race competitors. Louise Thaden won the Power Puff Derby, Hollywood aviator Art Goebel was the winner of the mighty Dole Race, and Roscoe Turner won a record number of the most prestigious races. Races resulted in significant aviation advancements, including retractable landing gear, wing flaps, streamlined cockpits, and supercharged engines. The glamorous heroism of the Hollywood aviators roared to record heights.

**CLARA BOW'S RACY PUBLICITY FOR *WINGS* IN 1927.** Bow, with fiery red bobbed hair, embodied the upbeat flapper spirit. She was the Marilyn Monroe of the Roaring Twenties. After her next starring role in *It*, Bow became known as the "It Girl." She infused *Wings* with warmheartedness and spirited humanity. (Shawna Kelly.)

GARY COOPER AND FAY WRAY IN *LEGION OF THE CONDEMNED*, 1928. Clara Bow, who was in a romance with Cooper, landed him a brief role in *Wings*. This short-lived character part as a charming, doomed flyer was his breakthrough role. Wray married the screenwriter of this picture, John Monk Saunders, who was also a veteran combat aviator. (Marc Wanamaker, Bison Archives.)

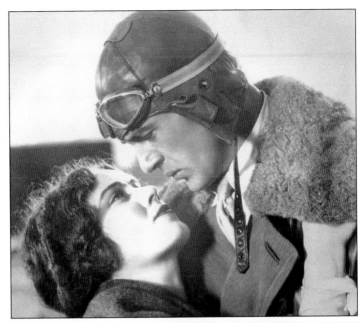

BEN LYON, JEAN HARLOW, AND JAMES HALL IN *HELL'S ANGELS*. "Would you be shocked if I put on something more comfortable?" was Harlow's famous line as Helen in *Hell's Angels*. Hall (third from left) played the upstanding aviator type, while his brother character Lyon (left) played the fearless playboy aviator type. A love triangle develops between Helen (Harlow) and the brother aviators. (Marc Wanamaker, Bison Archives.)

*Sincerely,*
*Viola Dana*

**DARING VIOLA DANA.** Dana was enamored with aviation. Mary Pickford's actor brother Jack was a good friend of Ormer Locklear and introduced him to Dana at DeMille Airfield. Locklear and Dana buzzed crowds over Venice Beach, Hollywood Hotel, and Hollywood Boulevard, where Dana would throw out lipsticks, compacts, and other souvenirs. When Dana was working, Lock would buzz, or "Beachey Bounce," the Metro studio by bouncing his airplane wheels on the hangar-like studios and everyone would shout, "There's Lock!" (Shawna Kelly.)

**ORMER LOCKLEAR AND VIOLA DANA.** The ultimate aerial couple of Hollywood is practicing aerial positions on top of a Curtiss Jenny JN-4D. Locklear and Dana shared a passion for flight and spent most of their time flying together. The 1980 documentary *Hollywood* (episode "Hazards of the Game") depicts a most moving portrayal of their Hollywood romance with the air. Had they been able to marry, they most likely would have done so in the air as Earl Daugherty and Catherine Hall did in an Orenco over Long Beach in 1923. (Art Ronnie.)

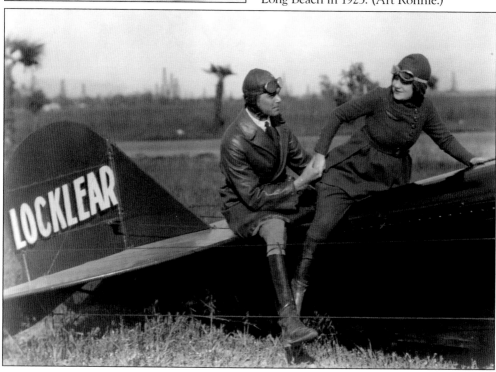

**ORMER LOCKLEAR, JACK DEMPSEY, AND VIOLA DANA.** Dempsey's fight manager was so concerned about the heavyweight champion flying with Locklear over DeMille Airfield that he threatened to call the police. Dempsey just laughed and went on his thrilling first flight with Locklear. Locklear did loops, tailspins, and stunts all over the sky. (Shawna Kelly, DeLay Heritage Collection.)

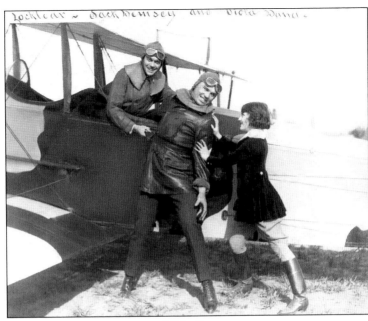

**VIOLA DANA IN AVIATRIX COSTUME DESIGNED BY LOCKLEAR.** Viola Dana, originally known as Viola Flugrath, was an actor by age 11. She is seen here modeling her aviatrix costume, designed by Ormer Locklear. It was embroidered with gold wings and her initials, V. D. Dana had earlier been in a romance with comedy great Buster Keaton, whom Locklear had once accidentally almost dumped out of his airplane over Hollywood. (Art Ronnie.)

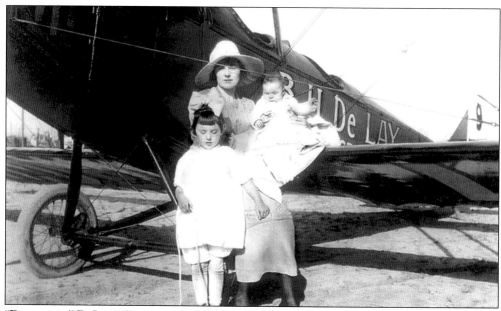

**"Daredevil" DeLay's Daughters Do Loop-the-Loops.** B. H. DeLay looped his baby Beverley and older daughter Patricia on occasions. Beverley became a Meglin Kiddie dancer like Shirley Temple. This is DeLay's wife, Juanita, who was a painter and pianist who performed at venues such as Carnegie Hall. Juanita's family ties include great writers such as Bliss Carmen and Ralph Waldo Emerson. After DeLay's "wings folded" forever during a performance on July 4, 1923, Juanita bravely operated a speakeasy. (Shawna Kelly, DeLay Heritage Collection.)

**Shirley Temple in *Bright Eyes*.** Proudly beginning her career as a Meglin Kiddie performer, little Temple became a big blockbuster star due to the Fox aviation film *Bright Eyes.* She won a special Juvenile Performer Academy Award after this 1934 performance filmed at Grand Central Airport in Glendale, California. She also sang her trademark song "On the Good Ship Lollipop" about aircraft in *Bright Eyes,* which sold 500,000 copies. Like many superstar leading ladies, Temple was enamored with her costar aviator in the film. Still a child star, she wishfully proposed marriage to the actor aviator James Dunn. A colorized version of *Bright Eyes* was produced in 2002. (Amélie Archives.)

**JANE WITHERS IN THE HOLY TERROR, RELEASED IN 1937.** Withers plays Corky Wallace, the irrepressible daughter of a lieutenant commander in the Naval Air who spends her spare time staging all-aviator theatrical shows. Corky's mission, with her pilot friends, is to try and save the day. (Amélie Archives.)

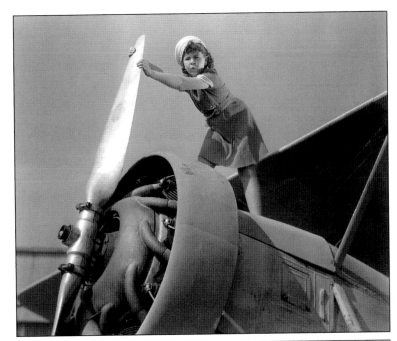

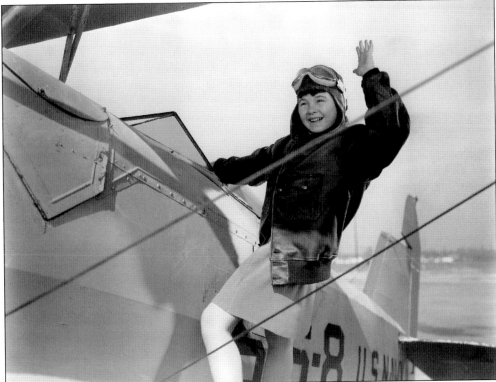

**JANE WITHERS GIVING A WAVE IN THE HOLY TERROR.** Withers exhibits wild abandon in this 20th Century Fox Production. After she played sassy Joy Smythe in the film *Bright Eyes*, she received a long-term contract with Fox and enjoyed a successful career as a child star. (Amélie Archives.)

**MARY PICKFORD CHRISTENING GRAUMAN'S CHINESE THEATRE–BRANDED AIRPLANE.** Pickford was a frequent spokesperson at airshows and a champion of aviation. Notice that aviatrix superstar Pickford is christening the airplane with a milk bottle since it is the Prohibition period. Note the elaborate dragon-skin detailing on the airplane. (Robert Nudelman, Hollywood Heritage.)

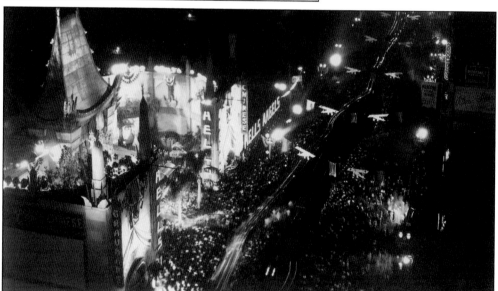

**GRAUMAN'S CHINESE THEATRE SPECTACULAR PREMIERE OF *HELL'S ANGELS*.** Theater impresario Sid Grauman emerged from retirement to stage the lavish premiere festivities for *Hell's Angels* (1930). Notice the airplanes hanging down Hollywood Boulevard. (Hollywood Heritage Museum.)

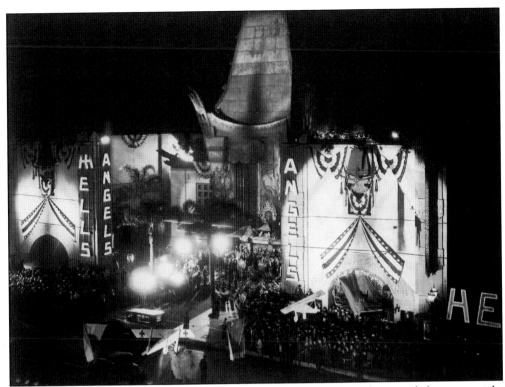

**GRAUMAN'S CHINESE THEATRE PREMIERE OF HELL'S ANGELS.** Stars who attended opening night included Charlie Chaplin with his girlfriend Georgia Hale, Buster Keaton, Mary Pickford with Douglas Fairbanks, Dolores del Rio, and Norma Talmadge. Premiering on May 24, 1930, *Hell's Angels* earned nearly $8 million at the box office—about double its production and advertising costs. (Hollywood Heritage Museum.)

**GRAUMAN'S CHINESE THEATRE OPENING OF HELL'S ANGELS WITH SUSPENDED AIRPLANE.** Notice chief aviator actor Frank Clarke's actual Fokker D-VII hanging in the forecourt of the theater. Clarke played the role of von Bruen and performed the most spectacular aerials in the film. He burned through five engines in this airplane. (Hollywood Heritage Museum.)

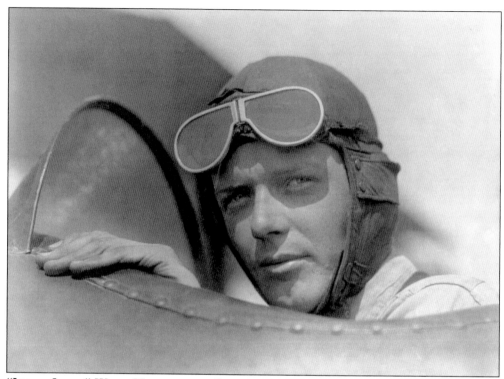

**"LUCKY LINDY" WAS A NICKNAME OF CHARLES A. LINDBERGH.** Lindbergh was an American aviator famous for the first solo, nonstop flight across the Atlantic in 1927. This record-breaking feat made Lindbergh the first international celebrity in the age of mass media. His airplane, the *Spirit of St. Louis*, also became famous and was the name of the film about Lindbergh. (Amélie Archives.)

**WILEY POST, FIRST AVIATOR TO SOLO AROUND THE WORLD IN 1933.** Post is featured in *Air Hawks*, a 1935 early science fiction movie filmed at Metropolitan Airport (now Van Nuys). Post was also a member of the secretive Quiet Birdmen with other legendary members such as Charles Lindbergh and Roscoe Turner. The organization convened at aviator-favored Roosevelt Hotel. Many people throughout the nation were crushed on August 15, 1935, when Post fatally crashed on takeoff from a lagoon in Alaska along with celebrated entertainer Will Rogers. Two national historic monuments at the crash site commemorate Post and Rogers. (John Underwood and Phillip Dockter.)

**AMERICA'S TOP ACE EDDIE RICKENBACKER.**
Rickenbacker earned the highest ace
ranking in America. Shooting down
enough airplanes in combat to qualify as
an ace is incredibly difficult to achieve. (It
usually requires at least five air victories,
but it varies from country to country.) The
French initiated this ace hero status, and the
Germans glorified this "acehood" with the
Blue Max medal for gallantry. The English
awarded the Military Cross and additionally
bestowed the Distinguished Flying Cross.
The "Hat-in-the-Ring" Squadron fought the
legendary Flying Circus led by the infamous
Red Baron [Manfred von Richthofen].
Rickenbacker soared into becoming the
most celebrated aviator in America and
refused many motion picture roles since he
had attained more than enough attention.
The 1936 film serial *Ace Drummond* is based
on Capt. Eddie Rickenbacker's writing and
character. (Amélie Archives.)

**WELL-DECORATED,
CHARMING ACE CHARLES
NUNGESSER.** This French
ace's dashing personality,
including his appetite for
danger, beautiful women, and
wine, epitomizes the archetypal
flying ace role. Nungesser
could sometimes be seen at
dawn, still in a tuxedo from the
previous night, being inserted
into his airplane for battle by
glamorous women. It is hardly
known that in the 1930 scenes
of *The Dawn Patrol*, Nungesser
was flying himself in his own
plane with the Knight of
Death emblem emblazoned
on it. (John Underwood and
Phillip Dockter.)

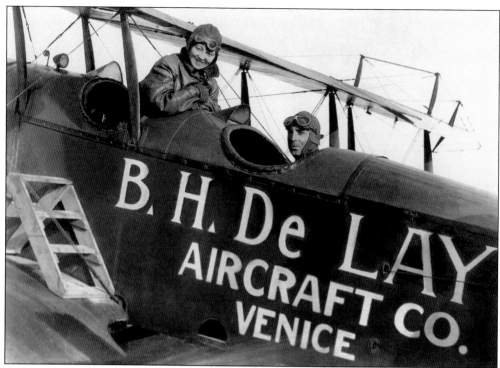

**PRINCESS FLYING WITH DAREDEVIL DELAY.** Native American Princess Tsianina (Cha-nee-na) was also an entertainer with singing talent. The Princess gave concerts throughout the country, often in San Diego with Charles Wakefield Cadman. An opera about Tsianina's life was performed at the Metropolitan Opera in New York. DeLay also flew opera star Tetrazzini while she sang high Cs in the clouds. (Shawna Kelly, DeLay Heritage Collection.)

**RUTH ROLAND AND MARY MILES MINTER AT THE FAMOUS FIRST FLY-IN.** The first ever fly-in only meet was at the Brand estate called El Miradero in Glendale. Mr. and Mrs. Brand are pictured with Ruth (left) and Minter (second from the right). Ruth's dramatic black aviatrix outfit had such an influence on aviatrix Anita Snook that Snook began wearing black and painted her airplane to match. See the following story about how Snook was saved at this wild celebrity bash. (Glendale Library.)

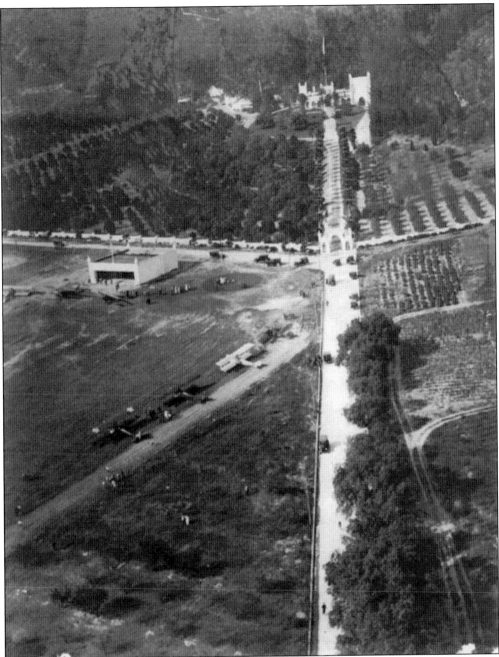

**FAMOUS FIRST FLY-IN AT BRAND ESTATE.** Leslie Brand hosted the first ever fly-in on April Fool's day in 1921. The gates were locked since no one was allowed entrance except by air. Over 100 celebrities of Hollywood aviation and notoriety arrived by airplane. Despite Prohibition, Brand's liquor bar was always overflowing for any visiting pilot. Anita Snook, a teetotaler who taught Amelia Earhart how to fly, took off while Daredevil DeLay was looping above the fly-in party. They ended up on a head-on collision path. DeLay anticipated that Snook was most likely to swoop upward, so at the last second he ducked his airplane below Snook's into the trees. He sheered off over two feet of his propeller, but he saved both himself and Snook. (Glendale Library.)

**MARY MILES MINTER (LEFT) AND CHARLIE CHAPLIN (RIGHT) ALONG WITH DOUGLAS FAIRBANKS ON THE COVERS OF AVIATION MAGAZINES.** Superstars Charlie Chaplin (right) and Douglas Fairbanks (center) pose at Chaplin Aerodrome in 1919 for *Tale Spins* magazine. The *Ace* magazine's cover article remarks that "Actor Minter is a proud long-term Aviatrix." (Hollywood Heritage Museum.)

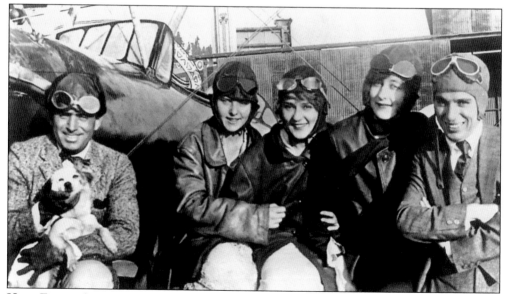

**HIGH-FLYING STAR COUPLES AND FAMILY.** The unabashed joy of flight is clearly seen in the expression of this flock of star flyers. In front of the plane are, from left to right, Douglas Fairbanks, Lottie Pickford, Mary Pickford, Mildred Harris (Chaplin's wife), and Charlie Chaplin. (Marc Wanamaker, Bison Archives.)

# Six

# EPIC AIR THRILLERS
## WINGS TO HELL'S ANGELS

Carl Laemmle, the founder of Universal Pictures, was the first producer to recognize and implement the potential of airborne thrillers. He realized that aviator stunts could prove to be the most popular scenes in any film. The spectacular aviation epics *Wings* and *Hell's Angels* pushed this realization to epic heights. These aerial action epics are full of behind-the-scenes fascination.

Director William A. Wellman served in World War I in the famed Lafayette Escadrille Flying Corps and strove for a high level of authenticity in *Wings*. Thirty-five hundred infantrymen and five dozen airplanes were enlisted for this elaborate film. The budget amounted to $2 million plus comparable government contributions. Dick Grace performed all of the four piloted crashes—and broke his neck—in the making of *Wings*.

*Hell's Angels* was another colossal undertaking. Director Howard Hughes invested over $500,000 acquiring and renovating a force of nearly 100 airplanes for production. As chief aviator, Frank Clarke commanded the film's nearly 80 pilots. Clarke also played the role of von Bruen and performed his character's aerials, burning through five engines for *Hell's Angels*. After a serious midair collision during the making of the film, Ira Reed chose to spiral down with his plane even though the colliding aircraft's pilot bailed out, and he victoriously saved his aircraft and self.

The *Hell's Angels* production cost an astounding record sum of $4 million. Hughes initially filmed it in the silent style but reshot it when sound was introduced in 1927, adding $1.7 million to the budget. Hughes oversaw 560 hours of footage (3 million feet of actual film), which was far and away the most footage shot for any motion picture.

*Hell's Angels* also involved one of the most scintillating movie premieres of all time at Grauman's Chinese Theatre in 1930 (see chapter five). Lavish international openings for *Wings* and *Young Eagles* also reflected high-quality aerial production.

Director Howard Hawks and writer John Monk Saunders's powerfully poignant film *The Dawn Patrol* (1930), for which Saunders won an Oscar, was remade superbly in 1938 at Warner Brothers. Epic cinematographers Elmer Dyer and Harry Perry were nominated for Academy Awards for their courageous cinematography. These foremost epics demonstrate the aviator's core values of courage, passion, and loyalty on a grand scale.

WINGS PROGRAM FROM 1927. The stars pictured in this Paramount program are Buddy Rogers and Clara Bow. *Wings* was the first major air epic and the first Academy Award winner for Best Picture. The screenwriter, John Monk Saunders, was an actual combat aviator. (Robert Nudelman, Hollywood Heritage.)

WINGS PROGRAM REVERSE. These are scenes from the breakthrough aerial epic, with close-ups of the stars. Pictured (center left) from left to right are Buddy Rogers, Clara Bow, and Richard Arlen. Kelly Air Force Base in San Antonio, Texas, also contributed pilots, aircraft, and technicians for this air spectacular. (Robert Nudelman, Hollywood Heritage.)

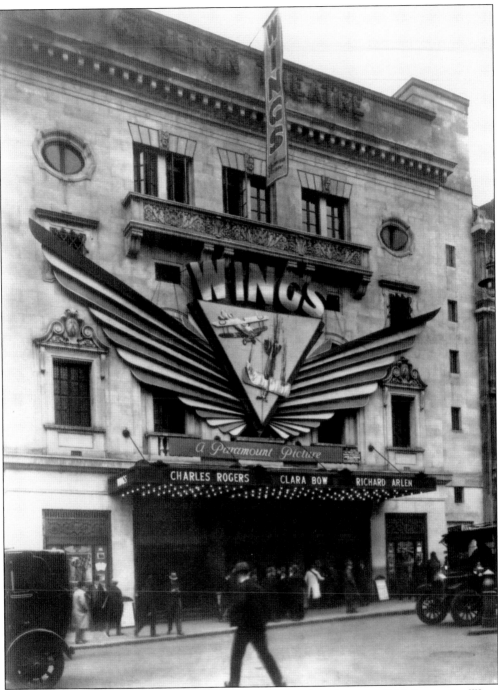

**WINGS IS A HUGE INTERNATIONAL HIT.** Observe the massive wingspan of this impressive *Wings* marquee. This aerial epic's success sparked the making of a multitude of aerial thrillers including the colossal production of *Hell's Angels*. (Marc Wanamaker, Bison Archives.)

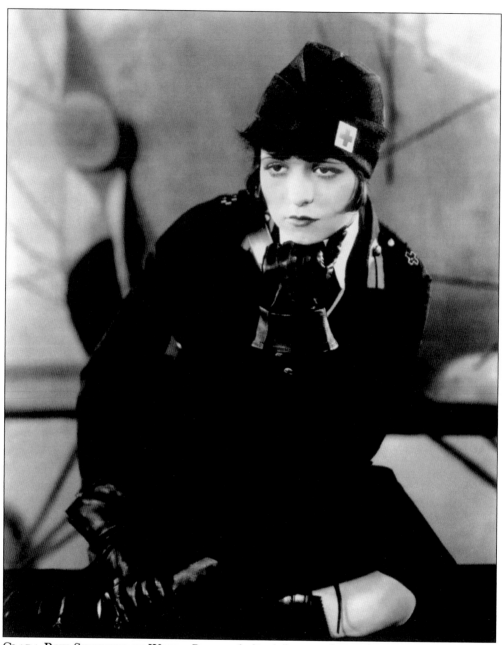

**CLARA BOW STARRING IN WINGS.** Bow symbolized the warmheartedness and passion of this major award-winning picture. She was elevated into a significant role model of the 1920s, defining the free-flying flapper lifestyle. (Amélie Archives.)

"Buddy" Rogers and Leading Aviators in Front of Dick Grace's Crash for *Young Eagles.* This 1930 shot from the Paramount film is by cinematographer Elmer Dyer. Pictured from left to right are Frank Clarke, Buddy Rogers, Dick Grace, Paul Lukas, Leo Nomis, and Earl Robinson. Nomis's last name was actually Simon, but he changed it to Nomis to be more unique for show business. (Marc Wanamaker, Bison Archives.)

*Young Eagles* Premiere in 1930. Notice the elaborate indoor airplane display as well as Rogers's smiling headshot pose similar to the one in the image above. The film also starred Jean Arthur. Directed by William A. Wellman, this is a story about a heroic combat aviator of the Lafayette Escadrille Flying Corps, in which Wellman valorously served. (Amélie Archives.)

**WINGS AERIAL CINEMATOGRAPHERS WITH DIRECTOR WILLIAM A. WELLMAN.** Wellman is pictured in the center with a pipe. Chief cinematographer Elmer Dyer is above him and slightly to the right. Notice the goggles worn by the cinematographers who flew while cranking. (Marc Wanamaker, Bison Archives.)

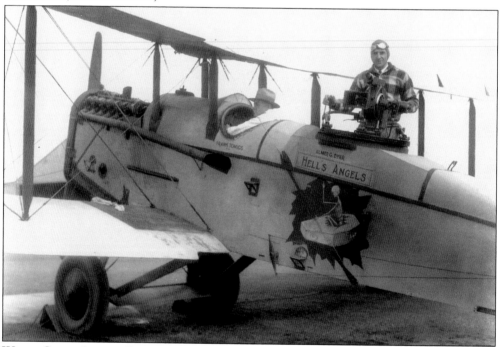

**WINGS CHIEF AERIAL CINEMATOGRAPHER ELMER DYER.** Dyer courageously captured *Hell's Angels* and many aviation films. He risked his life repeatedly for precise aerial sequences. The cinematographer for both *Wings* and *Hell's Angels*, Harry Perry invented the first remote airplane camera. He used a sewing machine motor and installed a remote switch for *The Broken Wing*, which was filmed on DeMille/Roger's Airfield. Both Dyer and Perry were nominated for Academy Awards for their outstanding aerial cinematography. (Marc Wanamaker, Bison Archives.)

**Harry Crandall's Smoke "Mask."**
This is what happens after smoke is released for dogfight crashes. Smoke releasing was a dangerous skill, since it could blind the pilot or filming pilots following in pursuit. (Marc Wanamaker, Bison Archives.)

**"Why Not, They Did It in Wings?"—Hell's Angels Humor.**
Howard Hughes is depicted as "Slim" near the bottom center. "Whoopee" Clarke is based on aviator actor Frank Clark, who was previously an advanced rodeo performer. "Baldy" is Roy Wilson, who permanently removed his hair by accident. Chief cinematographer Elmer Dyer is above him and slightly to the right. *Wings* was released in 1927, and *Hell's Angels* took off in 1930. (Marc Wanamaker, Bison Archives.)

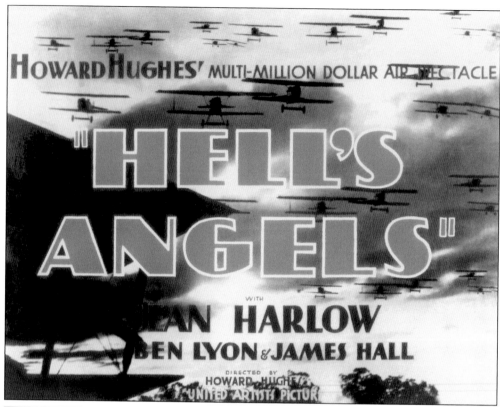

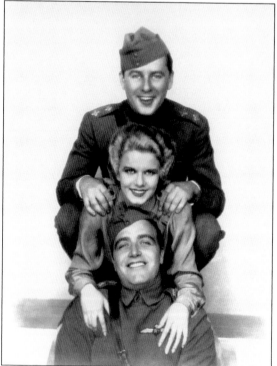

**HELL'S ANGELS LOBBY CARD.** The multimillion-dollar spectacle of *Hell's Angels* was well promoted with lobby cards (posters), detailed programs, live aerial exhibitions, and one of the most spectacular motion picture palace premieres in Hollywood history. (Marc Wanamaker, Bison Archives.)

**BEN LYON, JEAN HARLOW, AND JAMES HALL, *HELL'S ANGELS*.** This aerial epic was a breakthrough role for Harlow. The 18-year-old was cast to replace Norwegian-accented Greta Nissen when the film was reshot in sound. Lyon (on top) reinforced the film's authenticity with his flying experience from World War I. This trio becomes romantically entangled, exploring relationship freedom versus loyalty. (Hollywood Heritage Museum.)

**BEN LYON, JAMES HALL, AND FEATURED AIRCRAFT OF HELL'S ANGELS.** The lead actors of *Hell's Angels* demonstrate the depth of aviator loyalty. Hall and Lyon (right) are shaking hands in front of the emblazoned skull insignia on the Sikorsky aircraft. (Marc Wanamaker, Bison Archives.)

**HELL'S ANGELS GALLANT "HORSEPLAY."** Pictured from left to right are Al Wilson, Roscoe Turner, Jack Rand, Roy Wilson (kneeling), Frank Clarke, Garland Lincoln (whose head is visible above the saddle), Ben Lyon (on horseback), Frank Tomick, Jimmy Barton (kneeling), and Harry Crandall. (Marc Wanamaker, Bison Archives.)

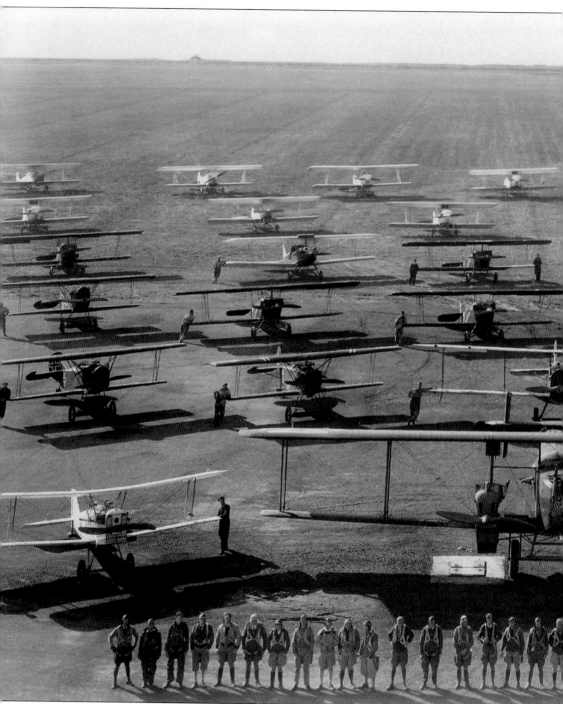

**AVIATORS AND AIRCRAFT FORMATION FOR *HELL'S ANGELS*.** This is a formation of over 60 pilots and nearly 40 of the 100 total aircraft used during the November 1928 filming. Leading aviators represented include Al Wilson, Frank Clarke, Frank Tomick, Garland Lincoln, Roscoe Turner, Harry Perry, Elmer Dyer, and Ira Reed. Note the Gotha (a modified Sikorsky) bomber's wingspan in the foreground. A few flyers gave the ultimate sacrifice in creating *Hell's Angels*:

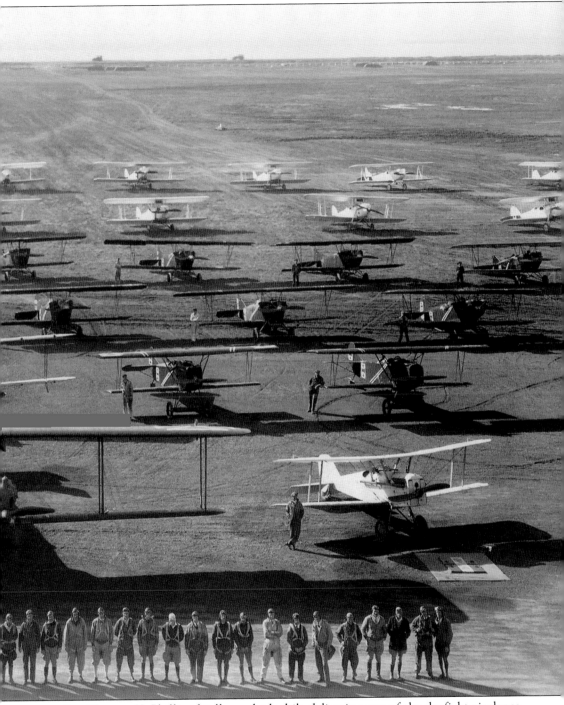

stunt pilot Clement K. Phillips fatally crashed while delivering one of the dogfight airplanes to the Oakland airport, Al Johnson of the 13 Black Cats had his "wings folded" when hitting high-tension wires, and Phil Jones was fatally trapped in the unintentional Sikorsky crash. (Marc Wanamaker, Bison Archives.)

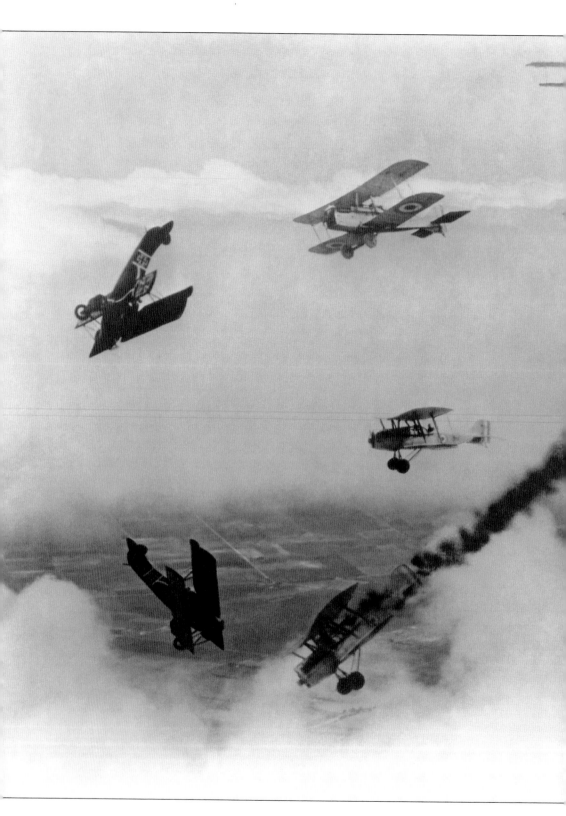

**HELL'S ANGELS QUINTESSENTIAL DOGFIGHT.** The daily expense of the dogfight for this magnificent epic sometimes reached over $160,000. The great dogfight between 15 British and 15 German planes took three weeks to film and cost $300,000. The budget of the entire film set a record at nearly $4 million, which would be well over $40 million today. Aircraft types filmed included Fokker, Sikorsky, Thomas-Morse, Jenny modified as Avro, and Travel Air. (Shawna Kelly.)

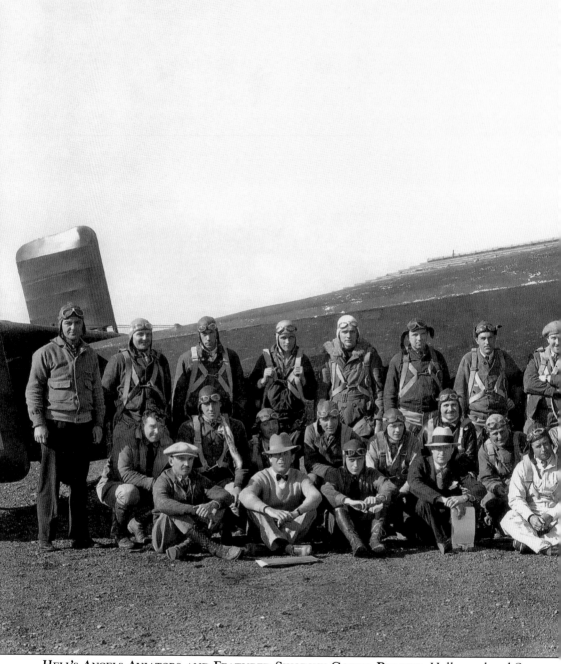

**HELL'S ANGELS AVIATORS AND FEATURED SIKORSKY GOTHA BOMBER.** Hollywood and San Francisco Bay Area aviators joined forces flying for Hell's Angels. Many of the pilots were well compensated as members of the AMPP union. Pictured from left to right are (first row) Harry Perry, unidentified, unidentified, Bob Starkey, J. B. Alexander, Billy Tuers, Jeff Gibbons, Frank Clarke, Ernie Smith, Al Wilson, R. A. Patterson, and Earl Gordon; (second row) Harry Reynolds, Ira Reed, Ross Cooke, Julian Wagy, unidentified, unidentified, George Willingham, George Parker, Garland Lincoln, Bob Starkey, J. G. Walsh, Clinton Herberger, and unidentified; (third row)

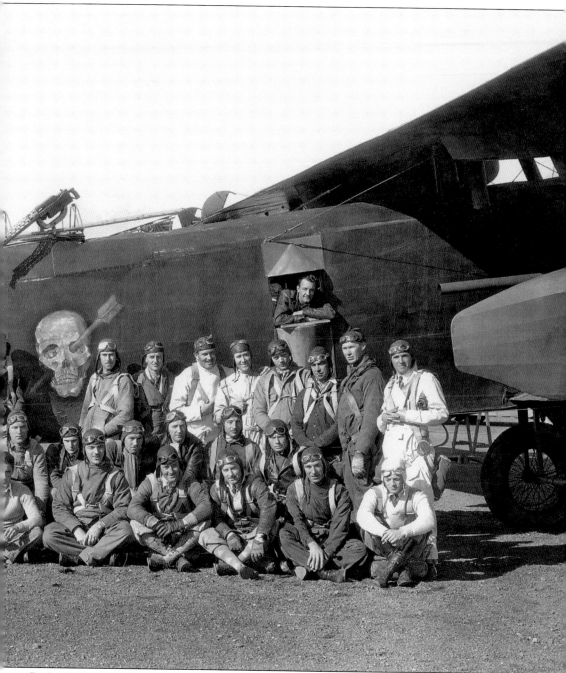

R. O. Shellaire, A. F. Mickel, John Penfield, unidentified, C. F. Sullivan, C. E. Dowling, George Ream, William Hank Coffin, Tom Penfield, Stuart Murphy, R. S. McAllister, Roscoe Turner, Burton Steene, Frank Tomick, Jack Rand, Harry Crandall, and Elmer Dyer; (leaning out of the Sikorsky window) Benny Colgren. (Roy Wilson, who played Baldy Maloney, is not pictured.) The headquarters of the motion picture aviators was Caddo Field on the edge of Van Nuys Airport, but some of the major dogfights were shot here at the Oakland Airport, especially for the fantastic cloud backdrops. (John Underwood and Phillip Dockter.)

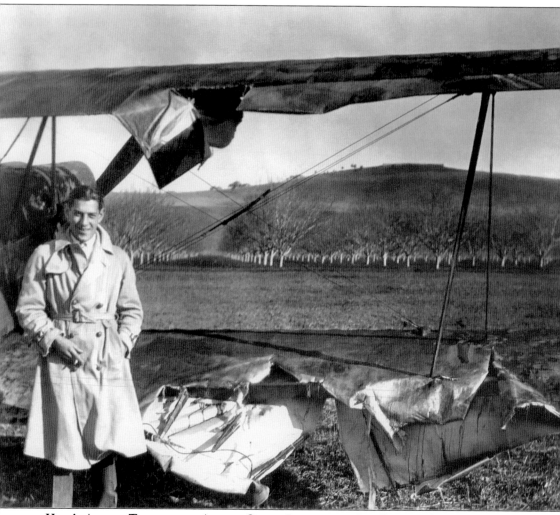

***Hell's Angels* Triumphant Aerial Crash Landing by Ira Reed.** When Stuart Murphy's and Reed's airplanes collided forcefully in midair, Murphy bailed out, but Reed risked his life to land the torn and scorched airplane he piloted. Reed became romantically involved with legendary Pancho Barnes, who thought highly of his passionate ways both onscreen and offscreen. (Robert Nudelman, Hollywood Heritage.)

**HELL'S ANGELS CRASH ESCAPES.**
Hollywood aviator Ira Reed should
have bailed during his near fatal
entanglement in midair with Stuart
Murphy, but he was determined to
save the airplanes. When Al Wilson's
propeller flew off while during one
of the film's dogfights, he bailed
and the airplane landed in film
producer Joseph Schenck's backyard
near Grauman's Chinese Theatre.
Schenck and his actor wife, Norma
Shearer, decided to retain the crash
monument in their backyard for years.
(Shawna Kelly.)

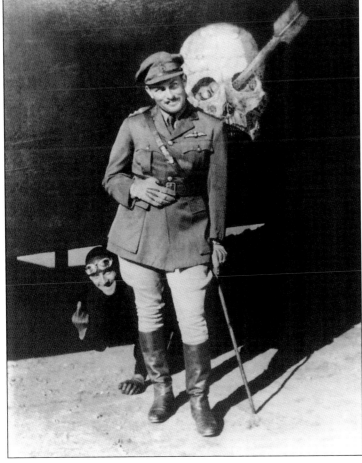

**ROSCOE TURNER
AND IRA REED.**
Turner (standing)
looks debonair in a
Royal Flying Corps
uniform in front of
his Sikorsky featured
in *Hell's Angels*, while
Reed displays his
underlying daring.
(John Underwood and
Phillip Dockter.)

DAWN PATROL LOBBY CARD FROM 1938. *Dawn Patrol* is one of the significant air epics and remains one of the most respected today. This Warner Brothers film from 1938 stars Donald Crisp, Errol Flynn, David Niven, and Basil Rathbone. Rathbone is forced to send under-prepared pilots in to fight against formidable odds. *Wings* writer John Monk Saunders won an Academy Award for writing the 1930 *Dawn Patrol*, which this film is a remarkable remake of. (Amélie Archives.)

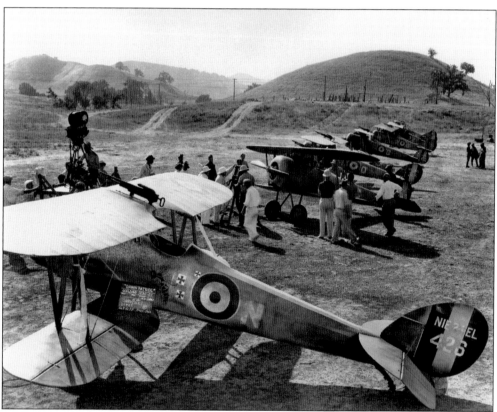

DAWN PATROL, 1938. Leo Nomis was the aerial sequence director for this film. The circular charge roundel insignia on this aircraft is derived from heraldry. Roundels are among the oldest charge symbols used in coats of arms, dating from at least the 12th century. Aviators carry on knighthood in the sky, flying inside of their "armor." (Marc Wanamaker, Bison Archives.)

# Seven

# HOLLYWOOD AVIATOR
# RETROSPECTIVES
## RISKING THEIR LIVES
## FOR THE LEGEND OF HOLLYWOOD

A great number of aviators gave their lives for Hollywood, including three during the making of *Hell's Angels* alone. A military pilot "folded his wings" in the making of *Wings*. Frank Stites was one of the earliest entertainment aviators to give his life for the industry during the opening of Universal City. Broken bones were common sorts of badges of honor.

One of the greatest motion picture aviation advancements, developed between the production of *Wings* and *Hell's Angels,* was the creation of the Associated Motion Picture Pilots (AMPP). This group's unity extended the power of motion picture pilots, improving nearly every aspect of their profession in terms of safety, performance, direction, and compensation.

The creation of the AMPP unfortunately did not alleviate the risk taken by pilots who performed earlier for the big screen. *The Skywayman* (1920) called for Ormer Locklear to execute a spiraling dive at night over DeMille Airfield. Searchlights were not cut off as the signal to pull out of the dive, and the result was a meteoric, fatal crash. Hollywood aviators conducted a procession tribute to Locklear in the sky and studios emptied, joining the procession through Hollywood. Daredevil DeLay was sabotaged while performing, and this incident remains a true life unsolved mystery. The depiction of stunt pilot sabotage in *The Lost Squadron* (1932), developed from a story written by motion picture pilot Dick Grace, contains many connections to the first real aerial sabotage and touches a poignant chord.

Many of the retrospective films featuring heroic aviators stand the test of time. *The Spirit of St. Louis* (1957), starring Jimmy Stewart, is about Charles Lindbergh and sheds light on the experience of record-setting endurance pilots. The breathtaking dogfights and passionate interactions are adrenaline pumping in the fighter pilot thriller *The Blue Max* (1966), starring George Peppard. Filmed with detailed authenticity, *The Great Waldo Pepper* (1975), starring Robert Redford, is a must-see about the barnstorming and film pilots. *The Aviator* (1985), starring Christopher Reeve, is an underappreciated airmail aviator adventure.

Leading Hollywood aviators felt that creating motion pictures was important enough to risk and give their lives for. These aviators were role models of invention, bravery, loyalty, and the pursuit of perfection.

"CRASH KING" DICK GRACE WROTE *THE LOST SQUADRON*. Strikingly similar to the first real-life aerial sabotage of a motion picture pilot, B. H. DeLay, this sabotage mystery film features motion picture stunt pilots, a tyrannical director, and wing tampering. The film's aerials were performed by DeLay's aviator crew, including Frank Clarke, Dick Grace, Art Goebel, and Leo Nomis. (Robert Nudelman, Hollywood Heritage.)

ESCALATING TENSION SCENE IN *THE LOST SQUADRON*. From left to right, Robert Armstrong, Richard Dix, and Mary Astor star in this film influenced by the unsolved mystery surrounding the DeLay sabotage. Ralph Ince (pictured on page 119), who played the role of Jettick the detective, plays the brother of Thomas Ince, the famous producer who also died under mysterious circumstances. The connection of Thomas Ince previously owning DeLay Airfield and working with Daredevil DeLay on films also deepens the eerie coincidences of the film. (Amélie Archives.)

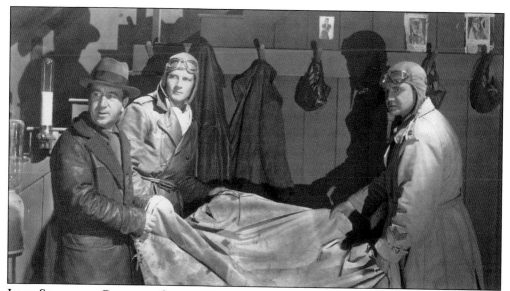

**LOST SQUADRON COVER-UP SCENE.** Pictured from left to right are actors Ralph Ince, Robert Armstrong, and Richard Dix. Real-life 1923 headlines announced that the famed flyer B. H. DeLay was sabotaged. The following saboteur events led up to the fiery crash described below: C. E. Frey, who insisted that he bought DeLay Airfield (yet had no paperwork proof), sent thugs to dig trenches on DeLay's airfield, blocking airplanes from taking off. Frey ended up in jail with DeLay and several others over the disturbance. DeLay was also shot at on Clover Field days before his crash. DeLay's sabotage became the first aerial murder case and remains an unsolved mystery. (Amélie Archives.)

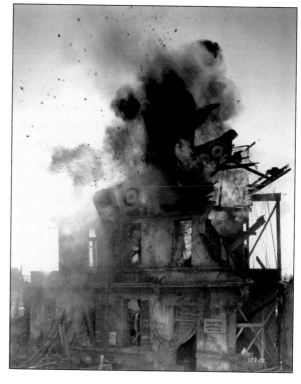

**AVIATOR DICK GRACE CRASHING FOR *THE LOST SQUADRON*.** The film was shot at Wilson Airport (now Burbank Airport) and Grauman's Chinese Theatre. Both onscreen and real-life Hollywood aviator crashes were often explosive. DeLay was performing loop-the-loops over crowds of thousands when his sabotaged wings folded back "as if on hinges," as reported by the *Los Angeles Examiner*. DeLay nosedived into the earth, and the airplane burst into flames. When later investigated, substandard sized pins were found in his wings, which indicated wing tampering. (Marc Wanamaker, Bison Archives.)

**GEORGE PEPPARD IN *THE BLUE MAX*, 1966.** This World War I air epic starred George Peppard as Bruno Stachel and Ursula Andress as the countess. This big hit appeals to those who enjoy either intensive action or romance. An intriguing portion of the movie deals with Peppard's character dogfight dueling with the infamous historical ace Manfred von Richthofen. Peppard was a hotshot onscreen and off, since he piloted his own personal Learjet. (Amélie Archives.)

***THE BLUE MAX*, BREATHTAKING THRILLER, 1966.** The intensity of the dogfight sequences in this Fox film creates a rush of adrenaline that makes it worth watching repeatedly. (Marc Wanamaker, Bison Archives.)

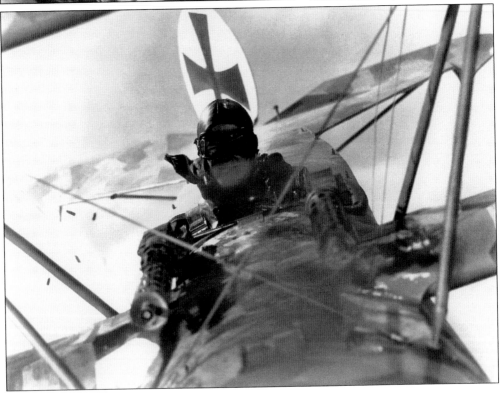

JIMMY STEWART AS CHARLES
LINDBERGH IN *SPIRIT OF ST.
LOUIS.* Stewart soars with a great
performance portraying Lindbergh
in this 1957 Warner Brothers classic.
This film is a virtuoso depiction of
endurance record-breaking aviators.
Stewart was an actual aviator who
became a colonel and squadron
commander before finally achieving
the rank of brigadier general, the
highest rank in military history
for an actor. Stan Reaver and Paul
Mantz performed the aerials. (Marc
Wanamaker, Bison Archives.)

CHRISTOPHER REEVE IN *THE
AVIATOR.* This United Artists 1985
film is an airmail pilot retrospective,
set in the 1920s. It also stars
Rosanna Arquette (left) and Sam
Wanamaker. Best known for his
leading role in *Superman,* Reeve's
natural acting contributed an air of
authenticity to this film. Reeve was
also a pilot. (Amélie Archives.)

**THE GREAT WALDO PEPPER AUTOMOBILE-TO-AIRPLANE TRANSFER.** Authentic attention to detail is displayed in this 1975 film's depiction of 1920s barnstorming and motion picture pilots. Susan Sarandon's character (right) is stunt driving for a barnstormer in this scene. The aerials were performed by Frank Tallman in a Standard J-1. (Marc Wanamaker, Bison Archives.)

**STOIC SCENE FROM THE GREAT WALDO PEPPER.** Margo Kidder convincingly emotes the frustration and passion of a daredevil's wife in the film. Redford's rival character, Ernst Kessler, is based on the real ace and stunt flier Ernst Udet. Many scenes in this Universal film display the various sides of barnstorming as well as the challenges onscreen and off for Hollywood aviators. (Amélie Archives.)

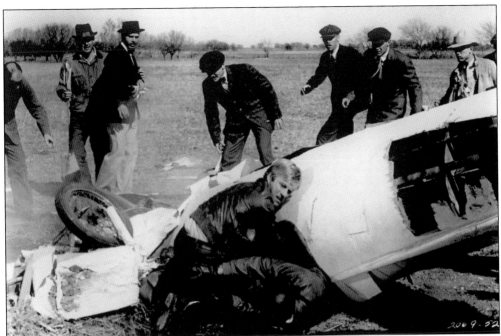

**POIGNANT SCENE IN *THE GREAT WALDO PEPPER*.** Waldo Pepper (Robert Redford) is pulling his friend Ezra Stiles (Edward Hermann) from a crashed airplane. Pilots who have "folded" their wings forever leave a huge imprint, as well as a void, in their family legacy. (Amélie Archives.)

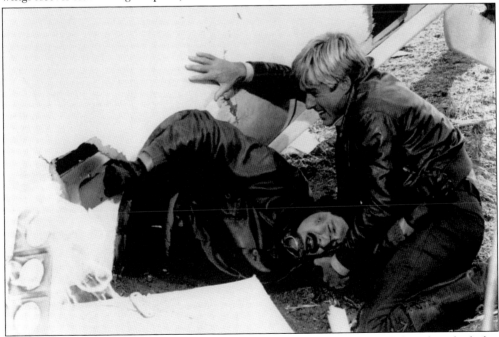

**INFAMOUS OUTSIDE LOOP IN *THE GREAT WALDO PEPPER*.** Waldo Pepper's friend crashed after a dangerous outside loop. In an outside loop, the pilot is upside down on the bottom of the loop, experiencing head-pounding negative g-forces. The first to perform the outside loop was Jimmy Doolittle, who became a heroic general in World War II. (Amélie Archives.)

**REAL-LIFE CRASH OF AMPP PRESIDENT WHILE FILMING SKY BRIDE.** This 1932 Paramount film stars Richard Arlen as "Speed" Condon, the leader of a barnstorming troupe of pilots. Leo Nomis gave his life during the making of *Sky Bride* at Metropolitan Airport (now Van Nuys) while performing aerial spinning. Poetically, a bird soars up to the light in the sky, as if taking over for the aviator. (Marc Wanamaker, Bison Archives.)

**DAWN PATROL AVIATOR VALOR TOAST.** In front of a Thomas–Morse Scout in 1938, David Niven, Errol Flynn, and Basil Rathbone salute aviators with "folded wings" and for better times. This is a profound re-creation of the bonding and immense pressures of battle. In addition to *Wings* and *Hell's Angels, Dawn Patrol* is a poignant epic. (Amélie Archives.)

# BIBLIOGRAPHY

*Ace Magazine*. Los Angeles: Ace Publishing Company: 1915–1923.

Caidin, Martin. *Barnstorming*. New York: Duell, Sloan, and Pierce, 1965.

Dwiggins, Don. *The Air Devils: the Story of Balloonists, Barnstormers, and Stunt Pilots*. Philadelphia, PA: J. B.   Lippincott Company, 1966.

Farmer, James H. *Broken Wings: Hollywood's Air Crashes*. Missoula, MT: Pictorial Histories Publishing Company, 1984.

Grace, Dick. *I Am Still Alive!* New York: Rand McNally and Company, 1931.

Greenwood, Jim and Maxine Greenwood. *Stunt Flying in the Movies*. Blue Ridge Summit, PA: TAB Books, Inc., 1982.

Hatfield, D. D. *Los Angeles Aeronautics 1920–29*. Inglewood, CA: Northrop University Press, 1973.

Kessler, Lauren. *The Happy Bottom Riding Club: The Life and Times of Pancho Barnes*. New York: Random House, 2000.

Ronnie, Art. *Locklear: The Man Who Walked on Wings*. Cranbury, NJ: A. S. Barnes and Company, 1973.

Stanton, Jeffrey. *Venice California: Coney Island of the Pacific*. Los Angeles, CA: Donahue Publishing, 2005.

Underwood, John. *Madcaps, Millionaires and 'Mose.'* Glendale, CA: Heritage Press, 1984.

*Venice Vanguard*. Venice, CA: 1918–1923.

Wellman, William Jr. *The Man and His Wings: William A. Wellman and the Making of the First Best Picture; Foreword by Robert Redford*. Westport, CT: Praeger Publishers, 2006.

www.centennialofflight.gov/essay_cat/12.htm

www.imdb.com/name/nm0209601

www.silentsaregolden.com/articles/aviationstuntmen.html

Wynne, H. Hugh. *The Motion Picture Stunt Pilots and Hollywood's Classic Aviation Movies*. Missoula, MT: Pictorial Histories Publishing, 1987.

# Index

# DISCOVER THOUSANDS OF LOCAL HISTORY BOOKS
## FEATURING MILLIONS OF VINTAGE IMAGES

Arcadia Publishing, the leading local history publisher in the United States, is committed to making history accessible and meaningful through publishing books that celebrate and preserve the heritage of America's people and places.

Find more books like this at
## www.arcadiapublishing.com

Search for your hometown history, your old stomping grounds, and even your favorite sports team.

Consistent with our mission to preserve history on a local level, this book was printed in South Carolina on American-made paper and manufactured entirely in the United States. Products carrying the accredited Forest Stewardship Council (FSC) label are printed on 100 percent FSC-certified paper.

**MADE IN THE**